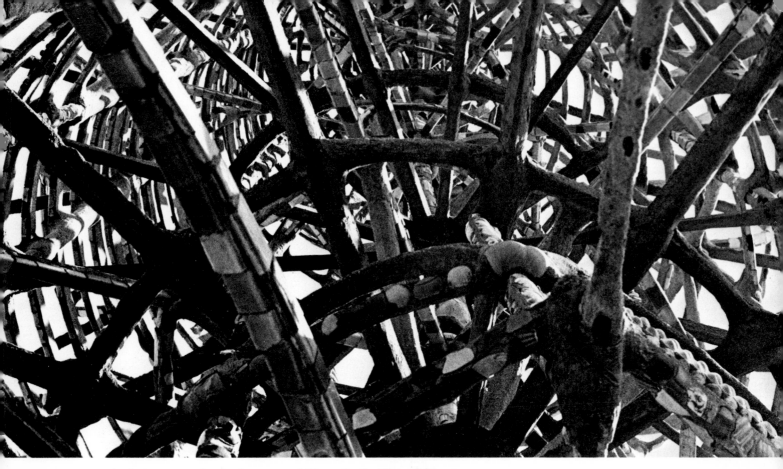

Intricate construction in the towers of Simon Rodia, Watts, California

WIRE SCULPTURE
and other three-dimensional construction

GERALD F. BROMMER

Art Teacher, Lutheran High School, Los Angeles, California

DAVIS PUBLICATIONS, INC., Worcester, Massachusetts

Consulting Editors: Sarita R. Rainey and George F. Horn

Copyright 1968

Davis Publications, Inc., Worcester, Massachusetts

10 9 8 7 6

Library of Congress Catalog Card Number: 68-19999

SBN: 87192-025-5

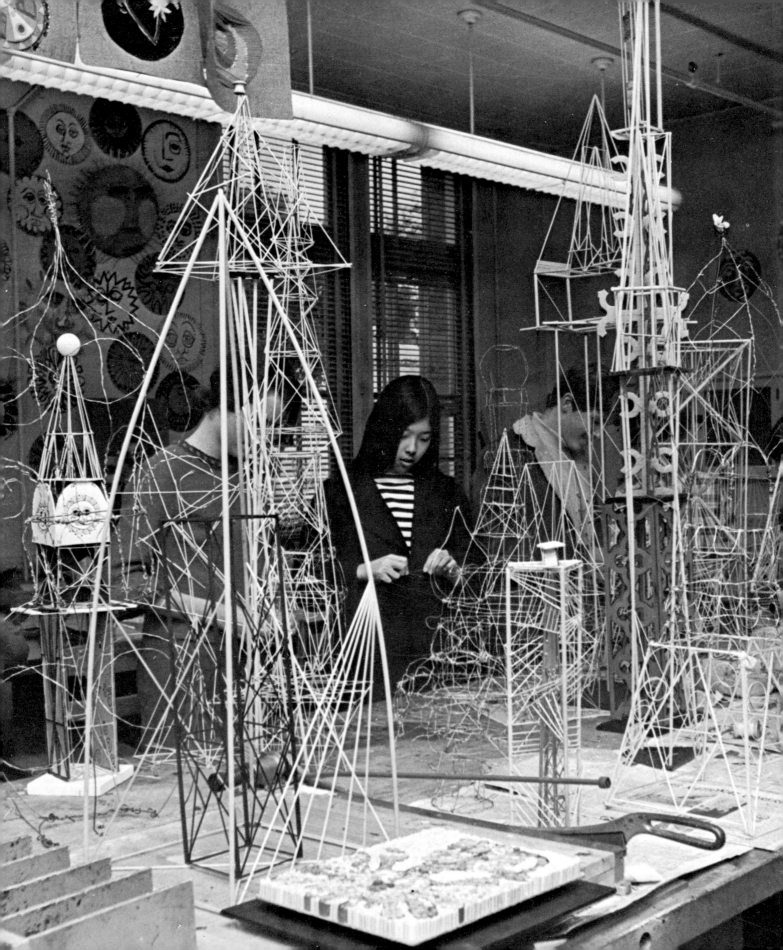

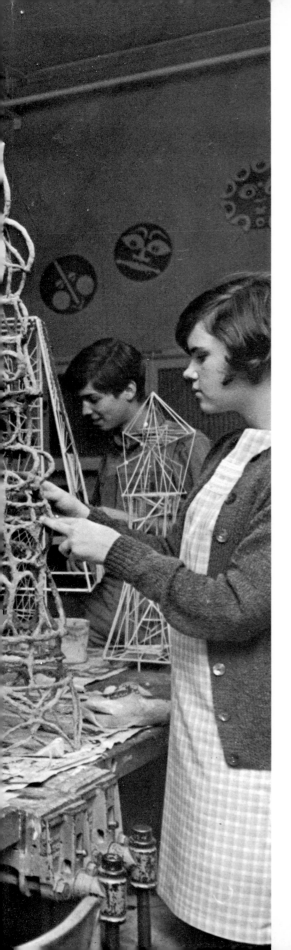

To Georgia and my many students who helped develop these ideas

CONTENTS

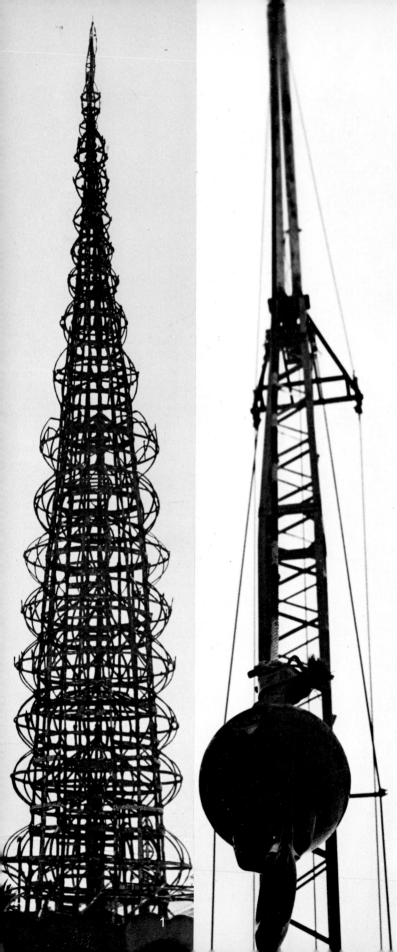

INTRODUCTION

Dynamic change is one of the plus factors of contemporary existence, so that by the time this book is published, there will undoubtedly be a myriad of newer ideas and techniques available. But this is the excitement of the latter half of the Twentieth Century—and it is to changing techniques in sculpture that this book addresses itself. And more particularly it will deal with sculpture techniques that are easily carried out in the art room, with a minimum of tools and equipment.

If you are intrigued by change, you should find stimulus here. If you are awed by change, perhaps within these pages you will find an approach that will make you friends with it. Let's jump into this sometimes confusing state of change and find out what it has in store for us. But enter with an open mind. What you read and see here will only be a whetting of the appetite, a springboard for real experimentation. Students who thumb through these pages should find a visual excitement that will stimulate their thinking and production. Let's see where it will take us.

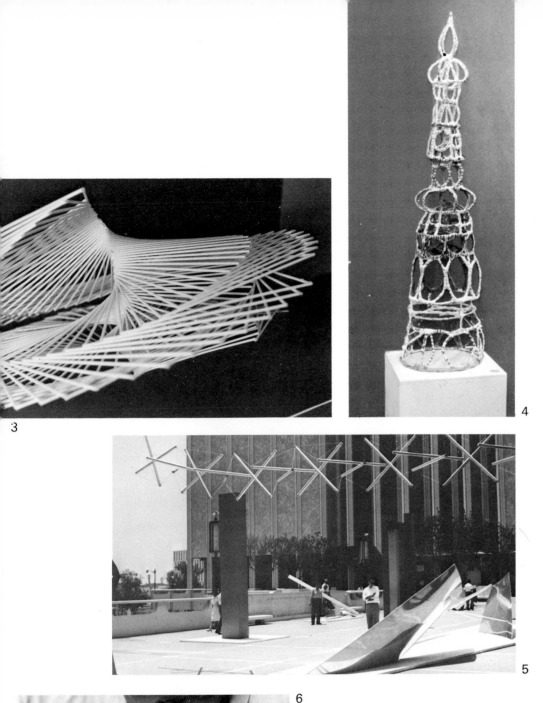

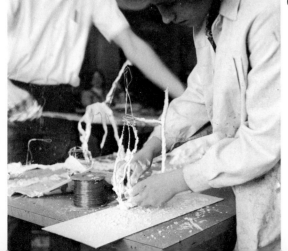

1. The graceful loops and spires of Simon Rodia's towers appear to be huge wire sculptures placed against the bright sky.

2. Strength and purpose are attributes of both construction and destruction cranes.

3. Dynamic structure is produced by gluing paper drinking straws together. Baltimore City Public Schools, Maryland.

4. Papier-mâché over a wire armature produces a sinewy construction. Le Conte Junior High School, Hollywood, California. (Los Angeles City Schools)

5. Sculpture patio of Los Angeles County Museum of Art holds variety of contemporary sculptures. The fascinating cable and tube structure is "Cantilever" by Kenneth Snelson. Courtesy Dwan Gallery, New York.

6. Eager hands manipulate wire and plaster.

Chapter I
AN APPROACH TO THREE-DIMENSIONAL CONSTRUCTION

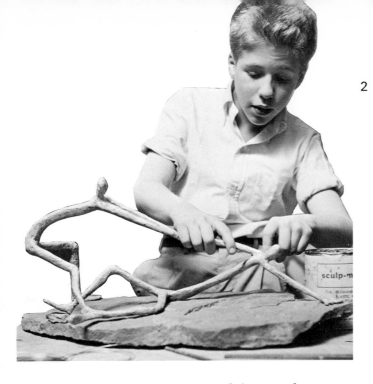

"DO NOT TOUCH!" are some of the most frustrating words ever lettered on a showcard. Don't you ever have the feeling, when passing a carving or a sculpture, that you simply must run your fingers over it? It is this drive to handle three-dimensional objects that prompts the sign to be placed near that sensuously carved piece of walnut, or that wondrously smooth polished marble surface. That one part *looks* textured, and I wonder how it feels alongside the smooth part. We'll never know, as long as we obey that sign.

But it is to the satisfying of this tactile frustration that this book is directed. I am sure that art teachers aren't the only ones who crave to touch such beautifully nurtured shapes and read them with their fingers, otherwise there wouldn't be the need for so many "DO NOT TOUCH" signs. And if this feeling is universal, or nearly so, how can we neglect having experience with three-dimensional work in our art rooms?

Besides satisfying a basic art need, working in three dimensions adds another form of communication to the working art vocabulary of the student. Perhaps there are things he wishes to say and show that he cannot articulate in two-dimensional media. It is possible that he can portray the delicate and unbalanced qualities of a young colt better in wire than in oils. Or maybe he can express strength more meaningfully with chunks of unfinished wood than with charcoal. Perhaps there are other reasons, but it is soundly important that three-dimensional work be handled at some depth in our art rooms.

1. "Volund" by Erik Gronborg is a large and rugged wooden construction bolted and strapped together.

2. Sculpmetal applied to a wire armature can be filed and polished to a soft luster. This one is mounted on a slab of slate. Courtesy the Sculpmetal Company.

3. Sculptured and decorated wood and cardboard boxes are bright and colorful. Le Conte Junior High School, Hollywood, California. (Los Angeles City Schools)

4. Gracefully carved pieces of wood are carefully selected and mounted on a lignum vitae base. Work is by John and Eileen Lee. Courtesy American Craftsmen's Council, New York.

5. Spindly-legged colt is of wire and sculpmetal. Lutheran High School, Los Angeles, California.

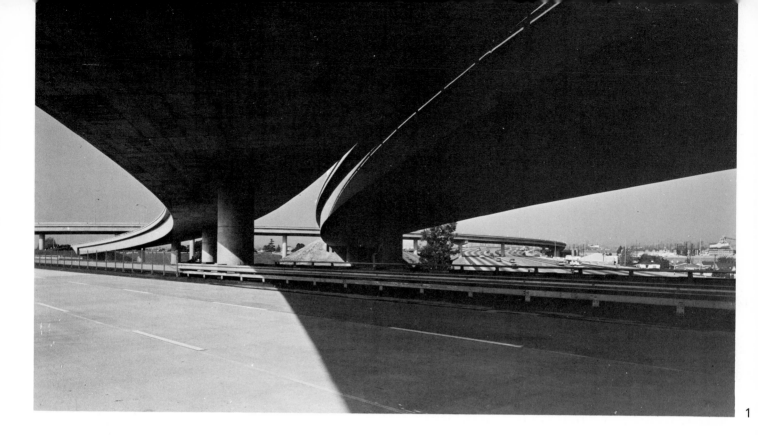

1

Three-dimensional work has traditionally been labeled "sculpture", and sculpture has come to mean designing in space. This is logical. Two-dimensional visual communication is painted, drawn, pasted or scratched on a flat surface, and occupies little space. A stack of fifty water colors takes up less than one inch on a shelf. But three-dimensional work occupies not only area, but takes up air space as well. Fifty sculptures could fill a room, occupying most of its air space.

Sculpture has long been a favored activity of creative mankind. Religious, social, and political life has been enhanced by three-dimensional figures. Until recent years, the sculptors have been interested in the solid form, in working with the organization of masses. Stone, wood, and clay were chiseled, hammered, and shaped to the artists' desires. And while the appearance of the products varied as years passed, the basic method of working on them did not change.

The advent of the Twentieth Century brought great changes in all forms of art. New materials and new meanings meant new forms in all fields of visual communication. Not only were painters working with new and exciting techniques, but sculptors also found an unending supply of new materials awaiting their creative and sometimes magic touch. Sculptures were not so much carving anymore, as

they were constructions. Welding, drilling, and gluing became part of the artist's vocabulary. Sawing, soldering, and laminating are part of today's art activity.

The constructive artist shucked the traditional forms of sculpture and dove headlong into the excitement of the Twentieth Century forms. From the cubists and the constructivists of the early 1900's we inherit a sensitivity for open areas in constructions, as well as the introduction of materials new to sculpture, such as string, paper, plastic, wire, and metal. The cubists also introduced the collage to the art world and the Dadaists picked it up and transformed this pasted and built-up application to three-dimensional forms in the art of assemblage. Movement was added with the mobiles of Alexander Calder, and design and technique were developed by Germany's Bauhaus School. And today there is literally no limit to the direction that sculpture might take.

Recent sculpture exhibits include in their work such materials as aluminum, plexiglass, plywood, painted metal, steel, rhodium plated brass, glass, neon tubes, plaster, perforated steel, acrylic resins, cloth, formica, plastics, rubber, vinyl, leather, wood, and stone. Anything that will work is legitimate material for today's artist. And the traditional display stand for sculpture has all but disappeared. Work hangs from

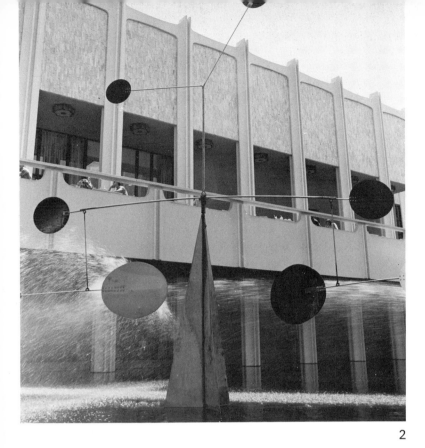

2

3

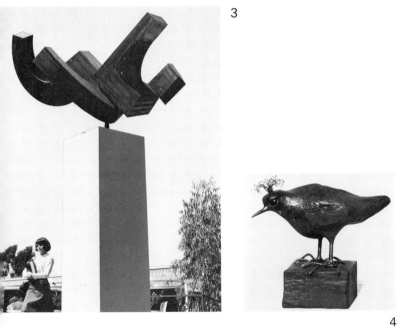

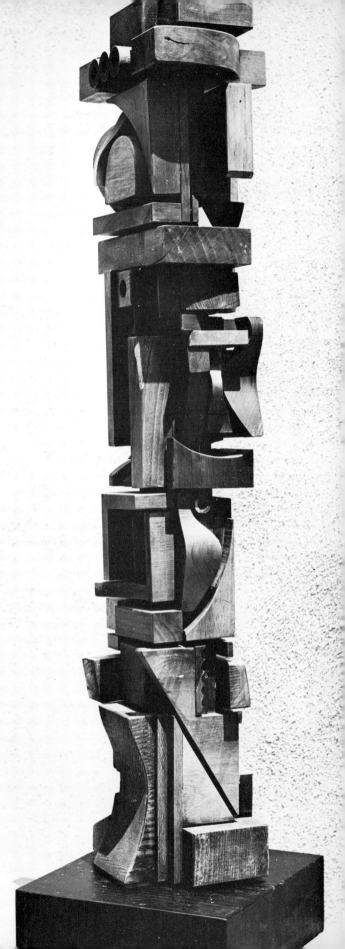

4

Dynamic contemporary constructions include freeway inter-
changes such as this one in Los Angeles. Courtesy the State of Cali-
fornia Department of Public Works.

"Hello Girls" is a painted metal construction by Alexander Calder,
and stands before the Los Angeles County Museum of Art. Courtesy
the Museum and the Art Museum Council.

"Long Beach Contract" by Gabriel Kohn is of laminated redwood
and stands on the campus of California State College at Long Beach.

"Alice" is composed of wood, steel, plastic and glass, and was
put together by Lou Rankin.

Mixed wood totem was constructed by Mabel Hutchinson.

5

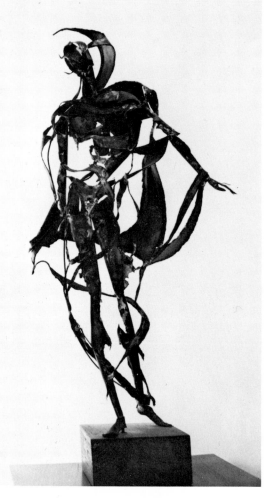

1

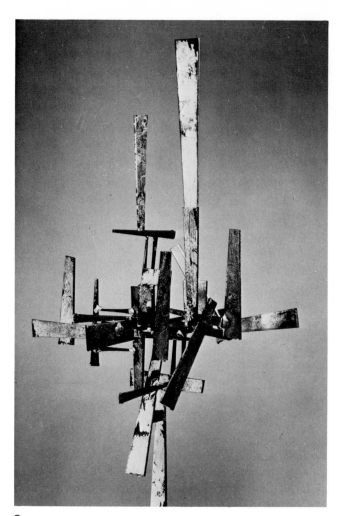

2

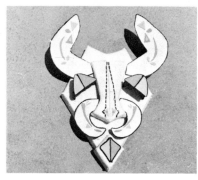

4

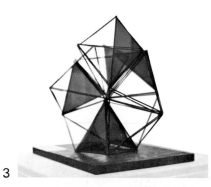

3

1. "Robed Figure" by Taki is of sheet copper, and is in the collection of Dr. and Mrs. Kalman Kurtzman. Courtesy the Carter Gallery, Los Angeles.

2. "Teruko" by William Bowie is of steel, and leafed with silver and gold. Courtesy The Sculpture Studio, New York.

3. Cellophane and wood structure is from Bancroft Junior High School, Los Angeles. (Los Angeles City Schools)

4. Mask is of cardboard structure and covered with burlap and a variety of other materials. Le Conte Junior High School, Hollywood, California. (Los Angeles City Schools)

5. Russ Shears designed this angry bird of welded wire and enameled parts.

ceilings, on walls, stands free on the floor, or leans against a wall. It might even be motorized and programmed to move, rotate, make noise, and/or activate a number of its parts. All this is wonderfully exciting and in a constant state of dynamic change.

Therefore, with all this going on outside our walls, three-dimensional art in our classrooms should be more than the two weeks of soap carving that our parents experienced. With the multitude of materials present all around us today, and the anticipated super-multitude that will surround us tomorrow, three-dimensional art should be an integral part of today's—and tomorrow's—art program. A visit to a contemporary sculpture show, or a visual jaunt through a sculpture exhibit catalog or current art magazine will jolt anyone into today.

Basically there are two types of sculpture—additive and subtractive. The type carried on by the artists of ancient Egypt, Greece, and Rome; by Michelangelo, Bernini, and the wood carvers of Oberammergau is all subtractive. Whether of wood, stone, plastic, or some other substance, if the artist begins with a blocked out shape and carves, saws, cuts or otherwise takes away from the original shape, he is subtracting from it. Therefore, when Michelangelo started with a huge block of marble and declared it was his intention to let the figure out of its rocky prison, he would subtract from the block until it was to his liking. The same holds true with the Bavarian wood carver, whittling on a piece of linden wood.

Additive sculpture is more recent historically, and is simply the opposite of subtractive work. The sculptor begins with a supply of materials, and from a starting point adds and adds until he is satisfied. These materials might be clay, wood, or metal; perhaps glass, lead, or plastic. They might be glued, nailed, welded, soldered or tied. By addition, therefore, the sculpture is brought to completion.

Quite naturally, additive sculpture takes on many forms. Fused glass will differ from wire sculpture. Welded steel will be different from laminated and glued wood. An additive clay figure will vary in form from one made with metal scrap. Here is the element of change. In additive sculpture, this factor of change will be a constant companion, because any or all of these methods might be combined into a single work. While carving of wood or stone holds certain limitations, working in any of the additive techniques will involve great areas of individual expression and freedom of change.

Working in clay, or any of the more traditional areas of paper sculpture and papier-mâché, although addi-

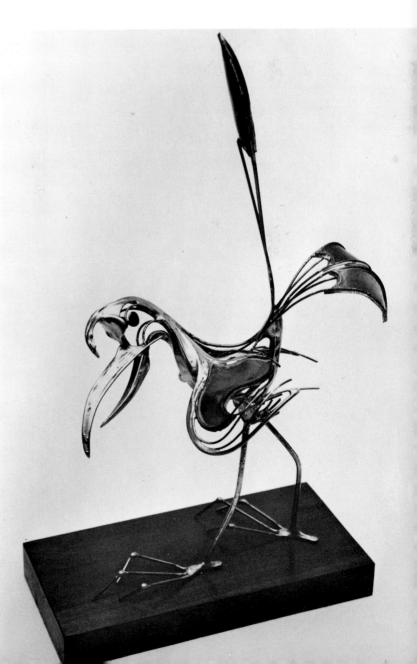

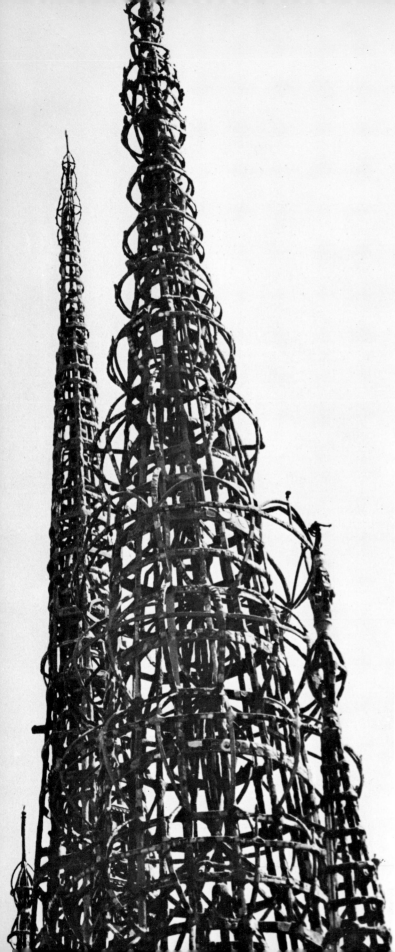

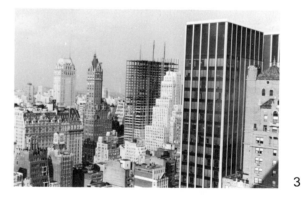

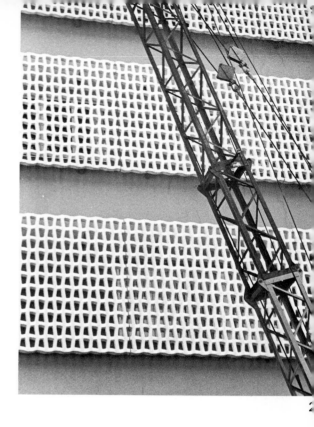

3

1. *The inventive creativity of Simon Rodia is seen in every aspect of his construction in Watts, California.*

2. *Textural concrete pattern and the framework of a building crane both provide studies in construction techniques.*

3. *Architectural construction in midtown New York, past, present, and future.*

4. *Eero Saarinen's "Gateway Arch" in St. Louis overshadows the newly constructed baseball stadium. The 630 foot soaring shape is the tallest monument in the country. Courtesy The Chamber of Commerce of Metropolitan St. Louis.*

5. *Look for construction techniques in ordinary places.*

1

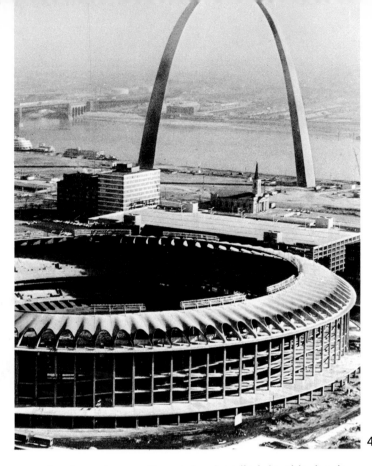

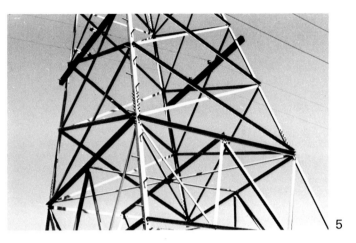

tive in nature, will not be handled in this book. Emphasis is placed on more recent developments in additive structure—on techniques perhaps better referred to as constructions.

The word construction has wonderful connotations: it involves a myriad of disciplines and thinking—engineering, aesthetics, form, space utilization, the flowing lines, the solid foundations, the cantilevered reach, and dozens of associated ideas. Look around you at the multitude of constructions—high rise buildings, automobile frames, wintered trees, electric high tension line systems, highway interchanges, erector sets and tinker toys, a wooden framed house, our rib cages, steel bridges, a chair, table, bookshelf, room divider, typewriter and clock workings, and on and on ad infinitum.

We only need to see the relationship between these utilitarian constructions and the artists' additive structures and we are well on our way to a new appreciation and understanding of three-dimensional construction. Sources of information and ideas are all around us, if only we see them.

Working in three dimensions allows for complete feeling of the finished work. Handle it. See it with your eyes shut. Notice its appeal to your tactile sense that should be encountered when working on sculpture as well as when viewing it. Handle three-dimensional work sensitively in front of

students so that their fingers itch to feel what you are feeling there.

View the work from a dozen different viewpoints—or more. Look at it from the top, the bottom, and all sides. Allow your eyes and hands to explore the recesses, run over the protrusions, size up the entire shape, delve into a detailed crevice. Get the feel of the third dimension—literally.

One of the things children like to do most is to nail pieces of wood together. Perhaps the scoldings given out by concerned adults in response to this activity frustrated most of us enough so that when we get a chance to go at it with encouragement, there is hardly any motivation necessary. Not only wood has this fascination, but any construction activity seems to bring out the latent builder in most people. Three-dimensional construction has become one of the most dynamic art forms introduced to the secondary student. Of course, uncontrolled construction has little value in the classroom. All elements of good art are as necessary in these activities as in painting or in carving. Concentration on rhythm and texture, on variety of shapes and sizes, is as important in forming a wire sculpture as in producing an oil painting. Balance and unity are as basic to a wood construction as to a figure drawing. But there are many pluses that can be added to the three-dimensional work: the tactile aware-

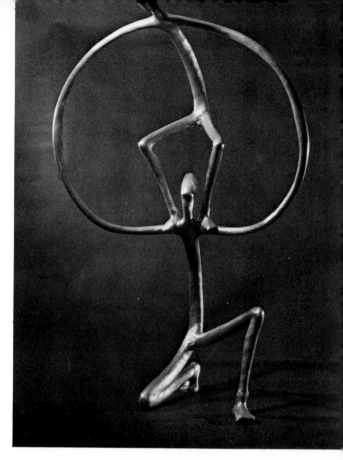

1

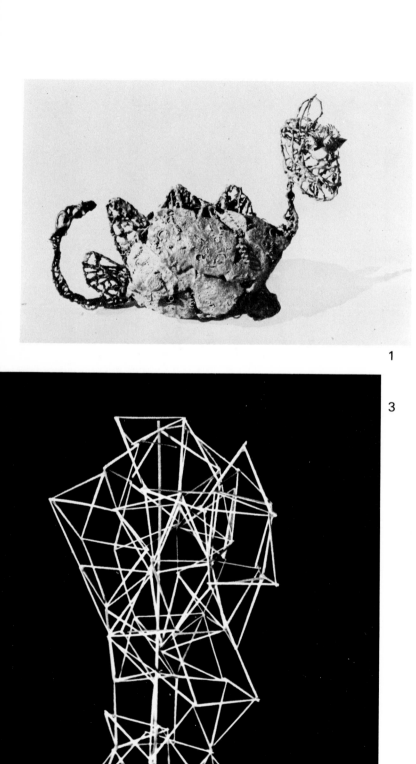

3

ness, the all-around appearance, the ability to add parts, the unrestricted sizes, and the sheer enjoyment and challenge of working in a new way with new materials.

Because of the tremendous variety of materials and types of three-dimensional construction possible, it is difficult to make a general statement regarding emphasis of design essentials. Various problems will require emphasis on various elements of the design spectrum. Wire construction usually emphasizes line quality, but by adding sheet metal creates a definite feeling of volume. Its decoration might be a smooth coat of color, or it might be a textured application of metal scrap glued to its surface. A wood construction can be spidery and emphasize a fragile and broken linear quality, or it might be a bulky solid shape depicting brute strength. Its finish might be polished smooth, or could be ragged, rough, and unfinished. It is this selection of materials, design qualities, and finishes that stimulates thinking. And it is in these decisions that the individual begins to emerge. Specific problems might emphasize line, shape, mass, volume, and deal with color, values, positive and negative shapes, and texture. All seem incidental to the construction itself, yet become a vital part in determining its value as a problem.

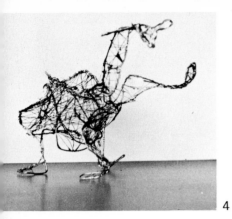

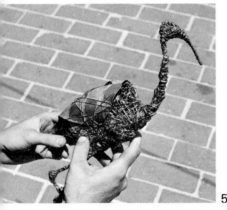

4

5

1. *Small monster of wire and sheet metal has beautifully textured surface. Lutheran High School, Los Angeles, California.*

2. *"The Acrobats" by Jules A. Petrencs is an aluminum sculpture of Sculpmetal over a wire armature. Courtesy The Sculpmetal Company.*

3. *Students encounter a myriad of construction problems when working on toothpick structures. Lutheran High School, Los Angeles.*

4. *Delicate wire is wrapped around a heavier armature to produce wobbly-legged creature. Lutheran High School, Los Angeles, California.*

5. *Wire bird has sheet metal wings colored with acrylic paint. Lutheran High School, Los Angeles, California.*

6. *Massive concrete constructions dot our current landscapes. These gently sweeping structures are in the Los Angeles freeway system. Courtesy State of California Department of Public Works.*

6

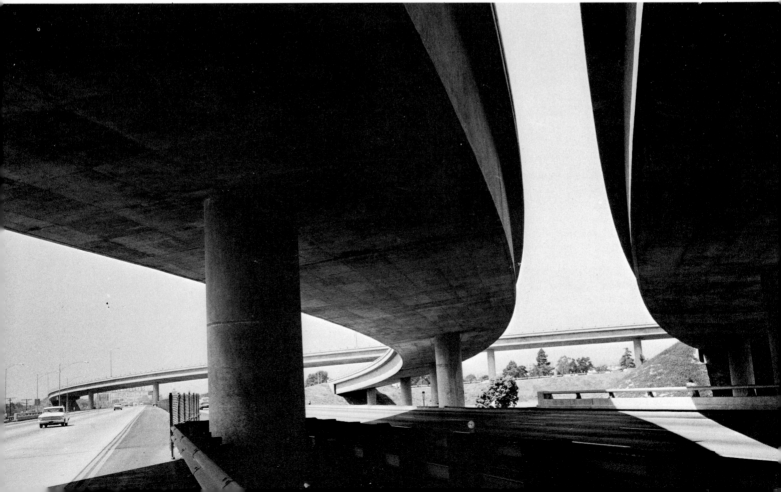

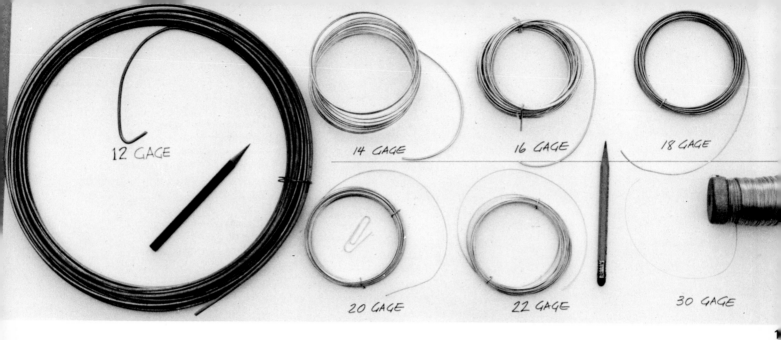

12 GAGE 14 GAGE 16 GAGE 18 GAGE

20 GAGE 22 GAGE 30 GAGE

Chapter II WIRE SCULPTURE

ABOUT WIRE

One of the most stimulating materials to explore in three dimensions is wire, which comes in a variety of forms, materials and sizes. However, a detailed explanation of the processes involved in producing wire, or a careful analysis of the types of wire produced will not help much in selecting the correct wires for use in your sculpture. It is much more important to find out what kinds of wire are available to you in your geographic area. Because of special uses, such as agriculture, steel production, or urban concentrations, special wires will either be available to you directly—or completely unavailable.

TYPES OF WIRE

The most generally available wires are produced of steel, either annealed or galvanized, with the latter more readily available to the ordinary purchaser. Copper, aluminum and brass wires are also available, but are more costly, unless local uses cause a generous supply to be consumed. Because of the ordinary cost factor, steel wires are recommended.

Wires come in varying degrees of hardness and therefore varying degrees of workability. Soft to medium wires will do well, if a selection is available. There is never any need for hard wire, unless someone donates a quantity for art room use.

Wires also come in varying sizes, called gauges in the steel industry. The gauge of steel wire differs a bit from other metal wire gauges, but to the wire sculptor this difference is negligible. Steel wire gauges range from 7/0 which is about a half inch in diam-

eter and a pound of which is only 1.56 feet in length, to 50 gauge wire which is .004 inches in diameter and a pound of which stretches for 19,366 feet or over 3½ miles. Neither of these extremes provides good material for the wire sculptor, but a range from 12 gauge to 30 gauge is most suitable. And these sizes are the most readily available.

Twelve gauge wire is about the thickness of most wire coat hangers, and 30 gauge wire is about as thin as is practical to work—about like regular sewing thread. This brief chart will show the diameter of these wires in inches and for ordering purposes, the length in feet of a pound of each gauge.

Steel wire gauge	Diameter in inches	Length in feet per pound of wire
12	.1055	33.7
14	.080	58.6
16	.0625	96.0
18	.0475	166.2
20	.0348	309.6
22	.0286	458.4
26	.0181	1144.0
30	.0140	1913.0

By comparing the extremes in this chart, an order of one pound of 12 gauge will bring you about 34 feet of wire while a pound of 30 gauge wire will bring almost 2000 feet.

HOW IS WIRE PACKAGED

Several kinds of steel wire are usually available at hardware stores and include regular soft galvanized wire, stovepipe wire in several gauges and in many

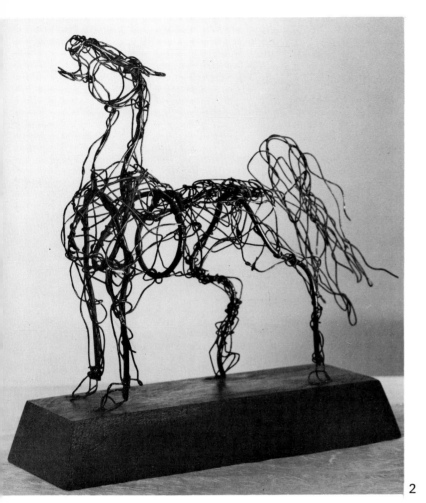

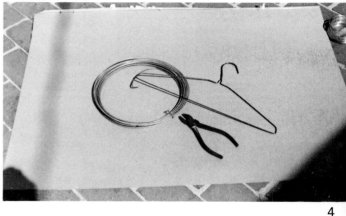

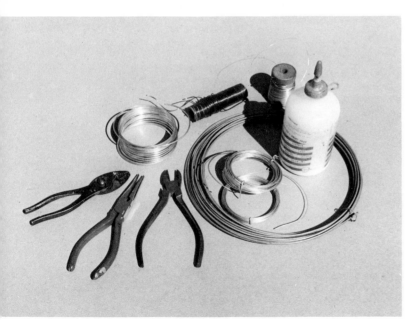

1. *The best wires to use for sculpture are from 12 to 30 gauge and made of galvanized steel.*

2. *Two different weight wires were used in this exciting sculpture. Florida State University School, Tallahassee, Florida.*

3. *All that's needed for a number of days of exploring wire sculpture is several gauges of wire, a few tools, and an adhesive.*

4. *Wire coathangers and 12 gauge steel wire are the same thickness, but the hardness of the hanger makes it difficult to work, although it is wonderful for certain purposes.*

1. *A coil of 14 gauge galvanized steel wire.*

2. *Some scrap pieces of electrical wiring left over from an installation job. Different colors can make attractive single piece constructions.*

3. *A coil of 12 gauge galvanized steel wire.*

4. *Three small coils of wire, easily obtained in a hardware store; 18 gauge galvanized steel, 19 gauge stovepipe wire and 20 gauge galvanized steel.*

5. *A single weight of wire was used in this construction, while two nails hold it to its base. The cyclist is from Dade County Public Schools, Florida.*

areas, baling wire. Florist supply shops contain large coils of various gauges of soft wire.

Baling wire can be bought in bulk or in convenient cartons produced by Bethlehem Steel. This wire is easily worked and is usually about 14½ gauge material. This might not be heavy enough for large size construction, but will be used a great deal in all wire work.

Bale tie wire, in pieces, comes in 12–16 gauge sizes, and has varying degrees of hardness. Use the softest available in your area.

Local needs might make box binding wire available to you. These wires come in 11–17 gauge thicknesses and can provide you with almost all the variety you might need. Newspaper tie wire, coming in 16 gauge thickness is a soft and easily worked material, but it probably will have to be purchased in 100 pound coils, unless a local publisher can help you obtain some in smaller quantities.

Stovepipe wire is a blackish wire, available in varying thicknesses, and is a very soft material to work with. Because of its softness, it is sometimes difficult to keep straight, and has a tendency to show every minor kink and bend, even after the material has been smoothed out.

Wires are available in a number of forms. Hardware stores generally sell them in ready formed small coils, which is the most expensive way to buy wire—but might be the only way it can be obtained in your area. A bit of shopping around might turn up a dealer who has wire available by the pound, which is the best way to get it. It can be bought this way from large coils which are perhaps two feet in diameter, and therefore a straighter wire than the tight, small coils available in some stores.

WHERE TO GET WIRE

All kinds of wire turn up when a class is asked to bring scrap wire from home for such projects. Coat hangers are good, but the wire is hard and is difficult to shape without tools. It does make firm armatures, however. Electric wiring used in house construction has a plastic coating which cannot be welded, glued or stuck together with sculpmetal, but the various colors can produce beautiful single-wire constructions. Very fine copper wire, usable for wrapping and adding details, can be unwound from old discarded motor or generator armatures. Other types of wire are also likely to appear in the scrap box from time to time, depending on local uses and parental occupations.

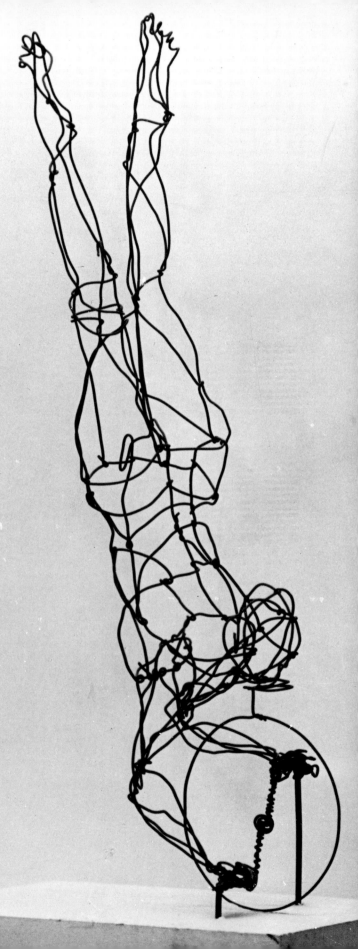

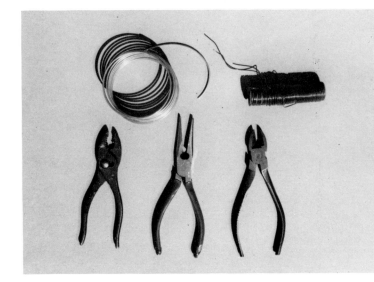

1

When wire must be purchased, there are several places to try. A first choice would be a visit to a local surplus store, which occasionally gets large supplies of various wires, and has them available at low cost. A visit to a steel service center, or aluminum supplier, might produce excellent results, especially if owners like to help the schools with price reductions. A shopping of yellow pages in the phone book for local dealers in wire, steel, aluminum, brass, copper might turn up some excellent sources.

If wire must be purchased at retail outlets, try large hardware stores, asking first for wire-by-the-pound. If they don't have this available, then pre-formed coils can be purchased in a number of sizes, depending on the intended use. Sometimes a local hardware dealer will order coils for stocking, if the school will make good use of his selection.

In agricultural areas, binder wire, binder ties and most other forms of wire are available in local hardware and farm supply stores.

WHAT SIZES TO USE
Several wires are all that are really needed in class, but the more types available the greater is the desire to explore the possibilities.

Twelve gauge wire is best used for armatures on large pieces. It is too heavy to work details, and too difficult for most girls to shape with ease. Very large pieces, those over three feet in length, should incorporate 11 or 10 gauge wires, as foundation structures. The best gauges for single piece constructions are 14 and 16, which also make excellent secondary wires in the more complex wire sculptures.

Thirty gauge wire is good for fine wrapping and tying larger wires together, but gauges up to 22 are also excellent for this.

If the only way to get wire is by sending away for it, order some each of 12, 16, 20 and 30 gauges. These four will provide every possibility for experimentation. But the very best way is to go to the wire and feel how it bends, holds shape, and can be worked—and regardless of its gauge, size, or material, get what seems to work best for your situation.

THE QUICK SKETCH APPROACH
Contour drawing in three dimensions? Simplification of forms and shapes? Another approach to the human form? Quick sketch wire sculpture might not be a cure-all, but it certainly has a broad range of application in the art classroom.

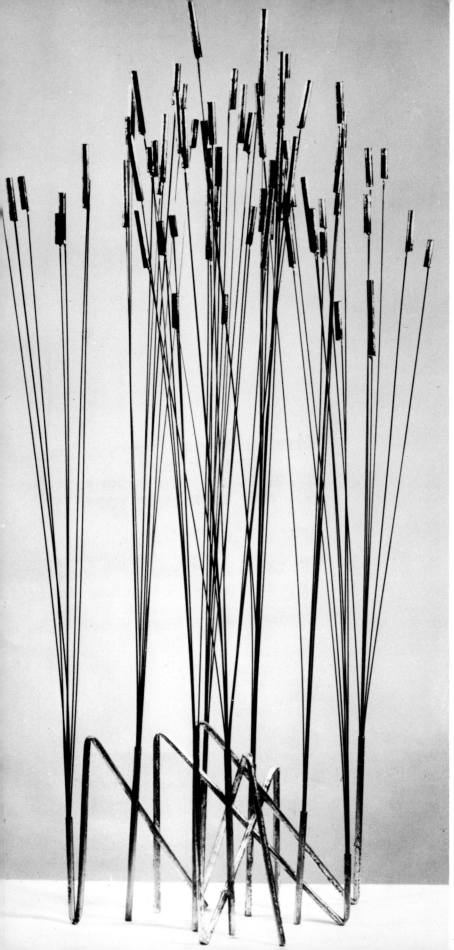

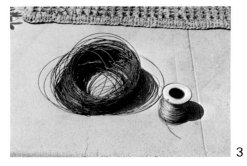

3

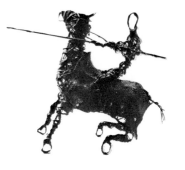

4

1. *A coil of 14 gauge steel wire and a roll of 14 gauge copper wire. The three most common tools used in working with wire are snub-nosed pliers, needle-nosed pliers, and side cutters.*

2. *Wire too stiff for bending easily? Got some tubing in the scrap bin and don't know what to do with it? Try a variation on the theme of "Cattails", a gold leafed, copper-coated steel rod sculpture by William Bowie.*

3. *Some joyful things turn up in the scrap bin, including this large coil of slightly rusted 18 gauge wire and the useful spool of brass wire.*

4. *Twelve and 20 gauge steel wire, a bit of window screen, and coat hanger wire for a lance, produce knight on horseback. Lutheran High School, Los Angeles, California.*

2

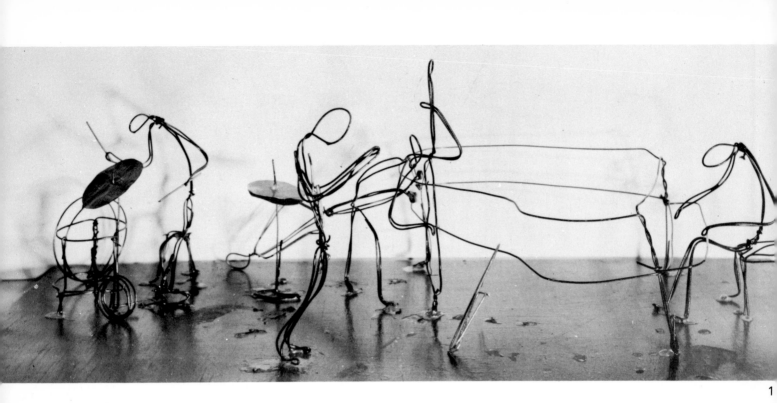

1

Among the earliest experiments in single-strand wire forming were those of Alexander Calder, many of whose smile-provoking sculptures are in New York's Museum of Modern Art. Most artists have not been satisfied with the simplicity of this approach, but it is here where wire sculpture should begin—in the uncomplicated and pure lines of a single wire construction.

Since wire is really line, it has already been twisted, pulled, crumbled, bent, stretched, and drawn in countless two-dimensional activities, and may already be classed as an old friend. The finished quick sketch wire structure can be silhouetted against the wall with a bright light, and immediate relation to contour drawing will be noted. It is easy to see that the simple forms "read" just as well if not better than more complicated sculptures of the same subjects.

MATERIALS

As a start, cut sections of easily workable wire into four to six foot segments. Place masking tape on the cut ends of the wire as a precaution against scratches. The wire selected should be easily bent by the girls, and should not need pliers to work it, except perhaps for a tight fold or two that will hold

the sculpture together. Steel wire is fine, but if aluminum wire is available, use it, because of its greater thickness and bulk and its easy bending quality. Even the plastic-coated electric wire, scraps of which electricians discard daily, is fine to use, and adds a dash of brilliant color, bends easily, and holds its shape.

You might want students to solder the wire in place, but this involves other problems and tends to destroy the quick and spontaneous approach, and the fluidity of the clean line. Pliers, cutters, shapers, and vises are used to advantage. Many unconventional tools may also be used, especially with the softer and more pliable wires. Coiling can be done around pencils or pieces of wood. Files can notch the wire to make sharp folds easier. Hammers can squash. Tape might hold one area together while work is done on another part. Girls might want gloves to protect their hands. Shaping and coaxing with the fingers is ideal, but in situations where the wire is too heavy for a small bend, or is simply uncooperative, basic tools should be employed.

PROCEDURES

As the student-sculptor holds a six-foot section of curling line in his hands, he will invariably ask,

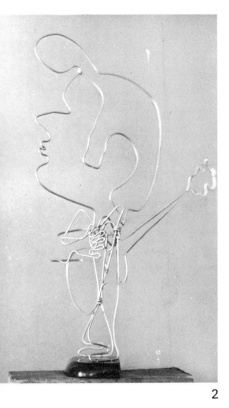

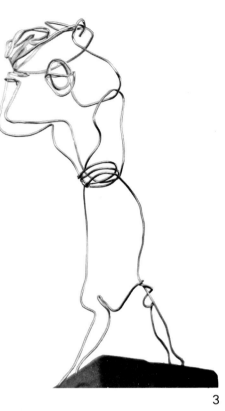

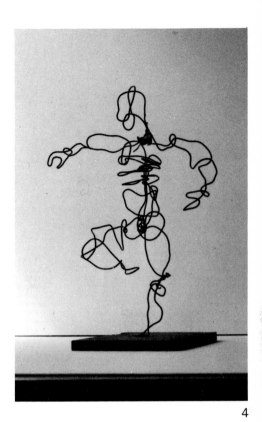

2

3

4

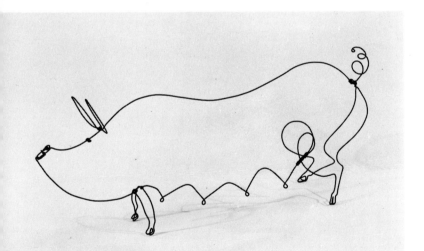

5

"Orchestra" is built of coathanger wire and metal scraps. Baltimore City Public Schools, Maryland.

Guitar strumming youth is formed of 12 gauge aluminum wire. Lutheran High School, Los Angeles.

Woman carrying load on her head is worked from a single strand of 12 gauge wire. Lutheran High School, Los Angeles.

Running figure is of soft steel wire, about 20 gauge. Lutheran High School, Los Angeles, California.

"Sow" is a 17 inch long wire construction by Alexander Calder. Collection, The Museum of Modern Art, New York. Gift of the artist.

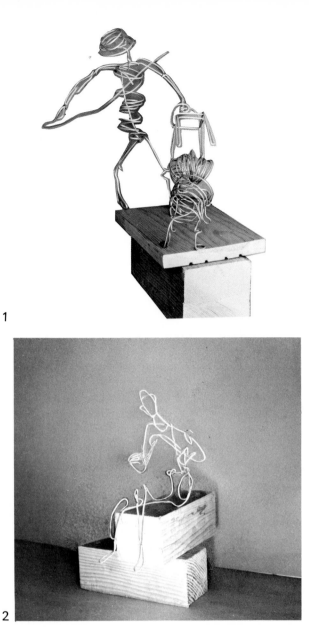

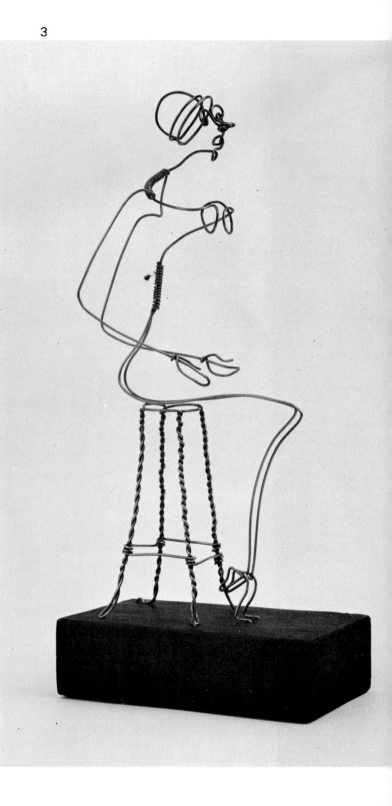

1. *Slightly balled wire figure is trying to ward off an attacking beast, also of balled wire. Lutheran High School, Los Angeles.*

2. *Quick sketch sculpture of person making a wire sculpture is formed of aluminum wire. Lutheran High School, Los Angeles.*

3. *"Soda Fountain", by Alexander Calder, is a small wire sculpture in the collection of the Museum of Modern Art, New York. It was a gift of the artist.*

4. *Wires used should be easily worked with the hands. Tools are essential at times, but most of the forming should be manual.*

5. *Box strapping wire was used to form this trombone player. Lutheran High School, Los Angeles.*

"What am I going to make?" Working with this single strand, in the quick sketch approach, the start may be in either of two ways. One young sculptor may have his finished form already in mind. Another may feel the quality of the wire, and begin bending and allowing the developing form to suggest its conclusion—which might be completely non-objective.

Any place on the wire may be the starting point for the shaping. Some find it best to begin about the center of the section and work the trailing ends simultaneously. Others like to begin at one end and work their way down the three-dimensional line, much like a contour drawing. Experimentation will determine which is better. This sinuous line can suggest many things, and will definitely inspire movement and activity. The illustrations will show that animal and human forms are easily created, since the need for complete representation is not desired. This allows for confidence in working with animal forms that might not be possible for some students in other media.

It is best not to be tied down to a sketch or a drawn plan. Allow the wire to lead into the sculpture. Look at the developing form often and correct it for proportion and shape from time to time.

Extreme action can be obtained by anchoring part of the wire on a block of soft wood and creating a cantilevered form. Such tension is conducive to vigorous movement. This three-dimensional line is easier to manipulate than a pencil because you don't have to erase when you want to make a change. Curve it, bend it, twist it, make the angles smooth or sharp, make the piece tall or short, make it restful or agitated.

Be sure that your sculpture is occupying air space— taking up room. Sometimes the first few pieces are simply flat wire forms, like a contour drawing, but with no third dimension. It is simple to add the missing dimension with a twist of the body, a bending of the arms or legs, and a curl of the wire to suggest volume. The sculpture should take up space in the round.

Action is easily imparted to a static form by a simple twist. Drawing the same problem would require a

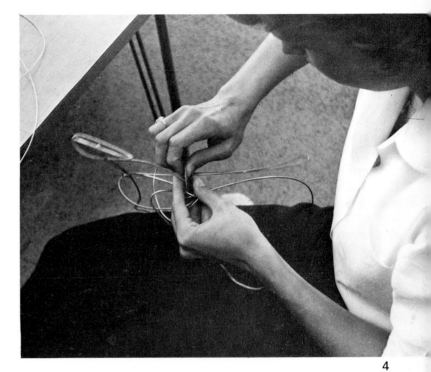

4

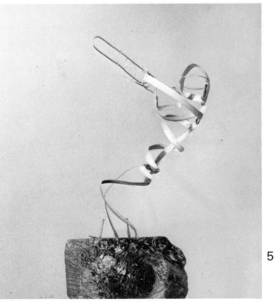

5

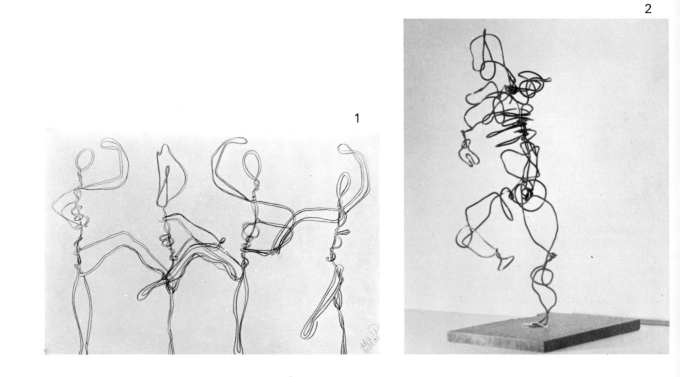

1

2

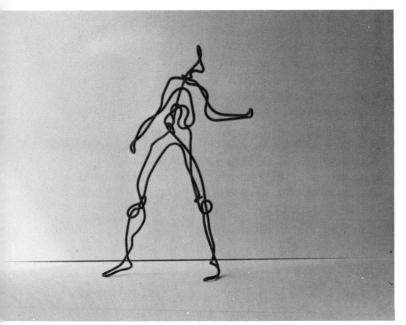

3

completely new start. Work until the figure stands by itself, then take a good look at it. Get your eye down next to the level of the work to see it. Turn it around and look at it from every angle. If it needs more bending or more straightening, bend it and look at it again. Don't quit until you are satisfied that it is as interesting as you can make it—from every angle.

OTHER IDEAS

People and animals and bugs are wonderful to construct of wire, but emphasize action. Animals can run and turn sharply, or skid to a halt, or bend down to eat. Two of them can chase, or fight. People can lift, push, pull, dance, run, jump, dive, swing a club, kick a ball, carry a pet, or sit and think. As part of the problem, make the sculptures free standing, or free sitting. This might require a bit of bending and balancing before it is completed.

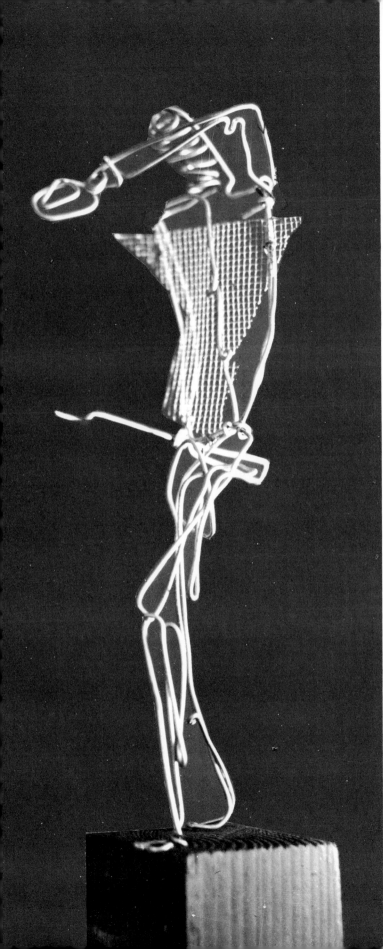

4

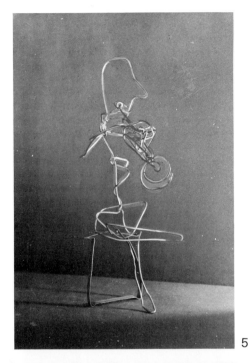

5

6

1. *Contour drawing of four views of the same single strand wire sculpture figure. Lutheran High School, Los Angeles.*

2. *Sprinting figure is of 18 gauge galvanized steel wire. Lutheran High School, Los Angeles.*

3. *Careful attention to muscle formations gives dynamic force to this single strand structure. Black painted sculpture is by Roland Sylwester.*

4. *Weary soldier is formed of aluminum wire and a bit of wire mesh. Richard Wiegmann formed this exhausted walking figure.*

5. *Trumpet player is of aluminum wire but he is sitting on a stool made of box-strapping wire. Lutheran High School, Los Angeles.*

6. *Single strand wire frog and a bug are formed of 18 gauge galvanized wire.*

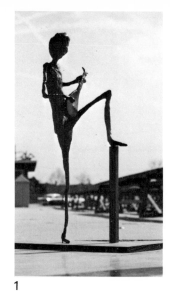

2

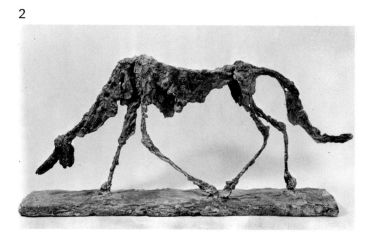

1

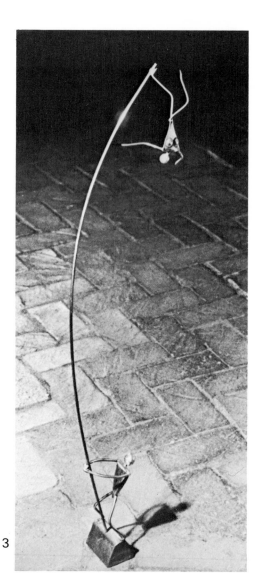

3

After several single-wire sculptures are made, perhaps you can work with two wires—or maybe two different types of wire, and allow for imaginative results.

As a follow-up activity, have students place their own, or a neighbor's sculpture in front of them, and make four continuous line drawings of it from four different points of view. For preservation, mount pieces on blocks of scrap wood, available from lumber yard boxes or the throw-away material from cabinetmaking shops.

TYPICAL PROBLEM/
QUICK SKETCH WIRE SCULPTURE

Human figure—done with six-foot single section of soft wire. Figure must be balanced and stand without support. Emphasis on movement and occupation of air space.

WIRE SCULPTURE/SOLID FORMS

One of the intrinsically good aspects of simple wire sculpture is the spontaneity and pure line quality. And in the forming lies its value, since the act of spontaneous creation is so vitally important. But this delicate and fragile quality is also a drawback, because what is easily formed is also easily deformed, and perhaps ruined.

A degree of permanence can be obtained by coating the simple wire sculpture with a liquid metal or plastic resins that can also be used for this process.

The goal is now to produce a more "finished" sculpture, one that has a quality of permanence. These sculptures will have much of the line quality of the quick sketch pieces but the lines will be more interesting due to their thick and thin variations in material and finish.

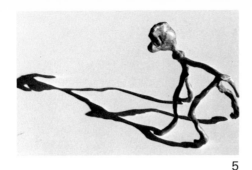

1. *Guitar strumming figure is of liquid metal covered wire, and is mounted on a walnut base. Lutheran High School, Los Angeles, California.*

2. *"Dog" by Alberto Giacometti. Collection, The Museum of Modern Art, New York. A. Conger Goodyear Fund.*

3. *"Acrobats" is a steel structure by Karl Larsson, and is owned by Dr. Philip Schultz.*

4. *"Jason" by Eduardo Paolozzi is a bronze structure in the collection of The Museum of Modern Art in New York. Blanchette Rockefeller Fund.*

5. *Wirey little dog is watching his own shadow. The liquid metal covered figure is from Lutheran High School, Los Angeles.*

6. *Figure holding a musical instrument is of liquid metal over a wire and mesh armature. Courtesy The Sculpmetal Company.*

7. *"Soaring" by Robert Cronbach, is of bronze and steel. Courtesy, The American Craftsmen's Council, New York.*

8. *"Man Pointing", by Alberto Giacometti. Collection, The Museum of Modern Art, New York. Gift of Mrs. John D. Rockefeller, 3rd.*

5

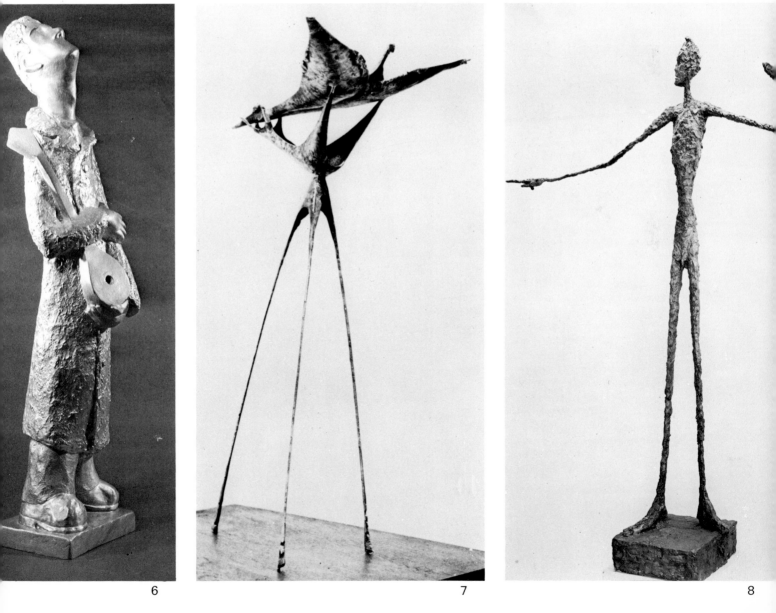

6

7

8

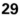

29

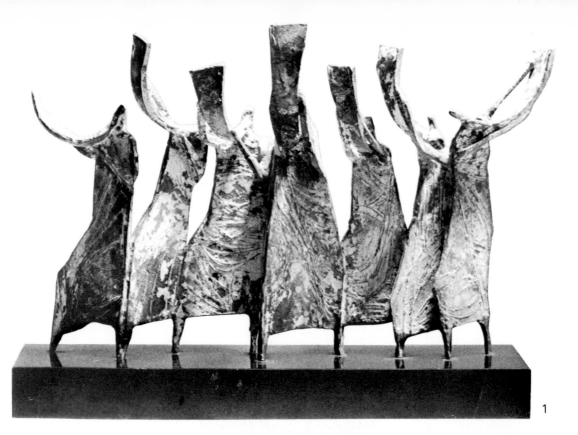

1. *"Trumpeters of Jericho"* by Luise Kaish is done in bronze. *Courtesy American Craftsmen's Council, New York.*

2. Polished liquid metal-over-wire figure for crucifixion is done by the author.

3. *"Messenger of the Gods"* by Edward Merrifield is built of liquid metal over wire and given an acrylic treatment for permanent outdoor installation. *Courtesy Orlando Gallery, Encino, California and Dr. M. J. de Carvalho.*

4. *"Stargazer"* is liquid metal over wire, left in natural aluminum color, and is by the author.

5. A strong wire armature is essential for a good liquid metal figure. Here 12 gauge wire is twisted for added strength.

6. Liquid metal being applied with a palette knife to a heavy screen armature. Successive layers will build up to a very workable surface.

7. Aluminum figures can be filed and buffed to a fine luster. Jefferson High School, Los Angeles, California. (Los Angeles City Schools)

8. Hurdler is in liquid metal over wire armature. Lutheran High School, Los Angeles, California.

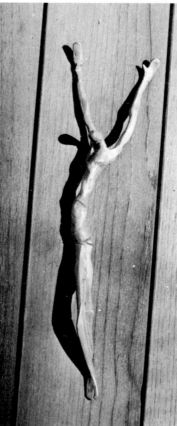

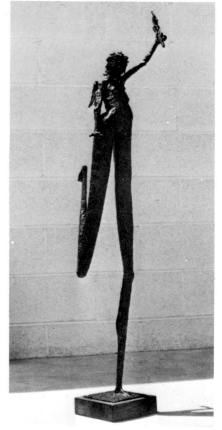

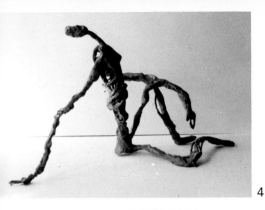

4

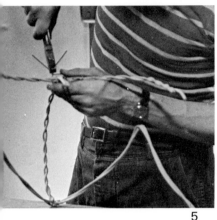

5

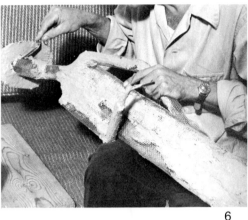

6

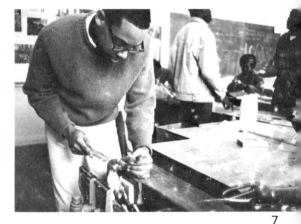

7

MATERIALS

Wire employed in this process should be as heavy as possible for the size of the work, and it should be bent and formed into a stable armature. The liquid metal that will be applied will add rigidity, but is not a very strong binding agent, and can easily be broken if joints are not secured in the basic shape. Unless the finished figure is to be painted, the wire should be of steel or aluminum so it will match the color of the plastic additive material.

Liquid metal is a very fine material to use for this technique. Body putty, obtained at automotive shops and various plastic resins and epoxies that can be filed and sanded are also usable. Correct solvents for all materials should be readily available, primarily for immediate clean-up use.

PROCEDURES

Using a good strong wire, form the simple basic shape and secure joints so the form is quite rigid. This can be done by tying the joining and crossing wires with finer wire or by twisting the armature wire around itself wherever possible to make the shape firm. The stronger this form is, the stronger will be the finished work. Since no changes in shape or attitude can be made later without breaking

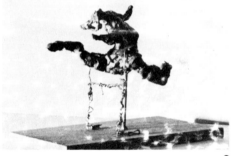

8

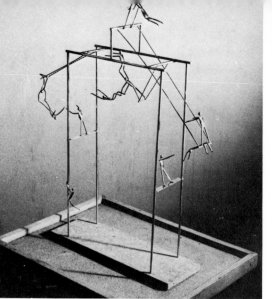

1

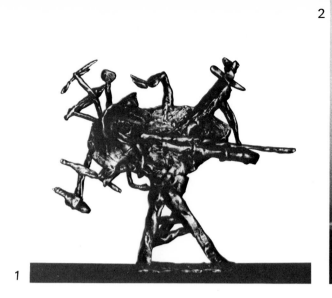

2

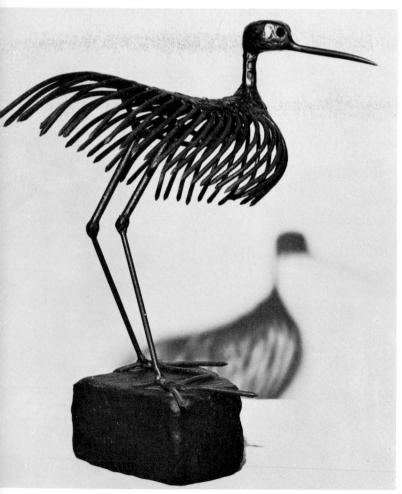

3

the covering material, the form of the armature should be analyzed carefully to make sure of its major movements and proportions.

This armature is now covered with successive layers of the coating material—allowing sufficient drying time before the next layer is applied. Material can be added with a disposable stick or applicator made out of wire, or with a brush. But be sure that all re-usable tools (like the brushes) are thoroughly cleaned with proper solvents, because the rapid hardening of the materials also makes for extremely difficult clean-up once the material has set. Generally, no more than 1/8 inch should be added at a time. Keep adding material until the desired volume or thickness seems to be developed. If a very thick volume is needed in places, it is better to form the shape from aluminum window screen or tin can metal or discarded aluminum or zinc offset printing plates, and put the filler material over these shapes.

When the sculpture is built up enough, allow it to harden completely. and then begin to refine. This now develops into a subtractive process of filing and sanding away rough and unwanted parts of the material, and working the sculpture to its finished shape. Large rasps and small files both work very well, and if clogged, can be cleaned with a steel brush or with the correct solvent.

OTHER IDEAS
A final buffing can be made with steel wool to give a dull lustre to the finish. The polished aluminum color will remain for years if kept indoors . . . or students may wish to paint the finished product.

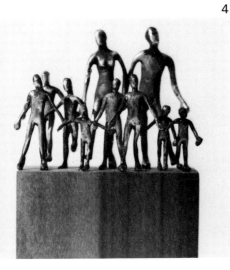

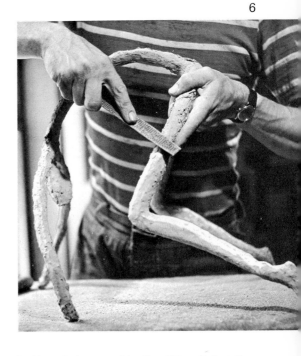

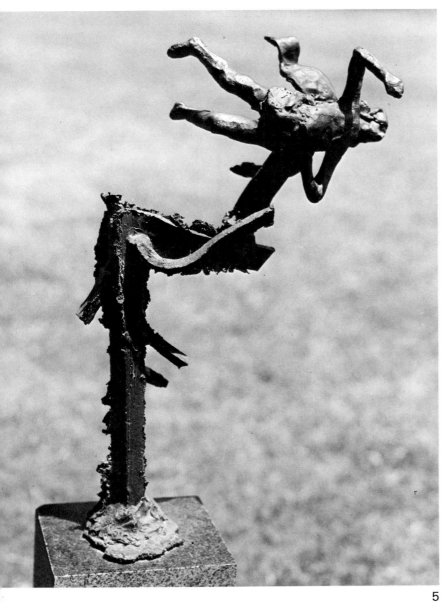

1. *Hana Geber cast this silver "Don Quixote".*
2. *"Acrobats" was done in brass by Karl Larsson.*
3. *"Bent Nail Bird" is welded of steel parts. By Lou Rankin.*
4. *"Family Group" by Robert Snider.*
5. *Small flying angel is by Arthur Geisert.*
6. *Liquid metal figure being filed to remove roughness obtained in application of material.*

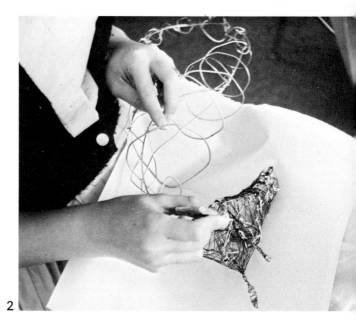

1

If the sculpture is to be placed outdoors, it can be coated with an acrylic or epoxy paint to prevent its weathering.

Small details can be added to the sculpture at any time by applying more of the material and filing or shaping it to the desired form. Varieties of finishes can be had by polishing parts of the sculpture and leaving parts of it rough, by allowing wires to remain visible in some places, by allowing file marks to show, by polishing to a high lustre, by mounting against a rough or smooth surface or block. Here again we encounter the elements of variety and change. There can be nearly as many solutions to problems as there are students in the class. Encourage experimentation of shapes, finishes, and attitudes. The visual materials presented here are only a sample of the variety you can expect. Look around at many of the small bronzes in galleries and museums, since a large number of these are adaptable to use in this sculp-metal technique.

TYPICAL PROBLEM

Animal form—preferably a long-legged variety. Armature of heavy wire, made simply and rigidly. Apply liquid metal to increase thickness and irregularity of line quality. File and finish. Sculpture's longest dimension not to exceed eight inches. Mount if necessary.

WIRE SCULPTURE/
OPEN WORK STRUCTURES

After a few single-strand constructions have been attempted, the young sculptors are perhaps ready

2

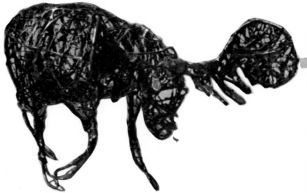

3

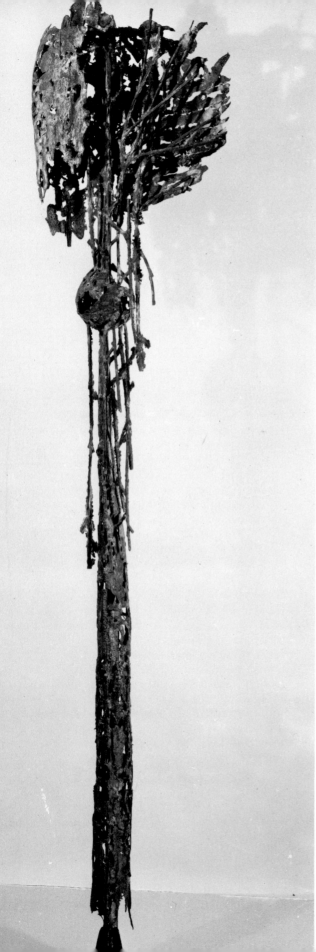

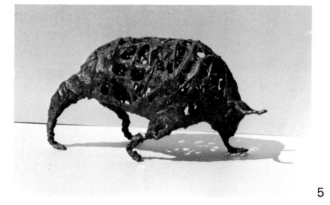

5

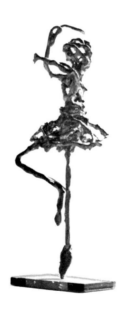

6

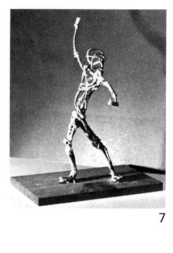

7

1. *Kiwi bird is of wrapped wire construction and strengthened with application of liquid metal. Lutheran High School, Los Angeles, California.*

2. *Fourteen gauge wire armature is wrapped with finer wire and adhered with liquid solder.*

3. *Charging moose has head weighted down with huge antlers. Lutheran High School, Los Angeles.*

4. *"Mutation" by Shinkichi G. Tajiri is of brazed and welded bronze. Collection, The Museum of Modern Art, New York. Gift of G. David Thompson.*

5. *Some portions are solid and others left open in this bull construction. Lutheran High School, Los Angeles.*

6. *Ballet dancer has elongated toe stuck into a hole in the walnut base to make her stand erect. Lutheran High School, Los Angeles.*

7. *Victorious youth of wire and liquid metal raises right arm in salute. Lutheran High School, Los Angeles.*

4

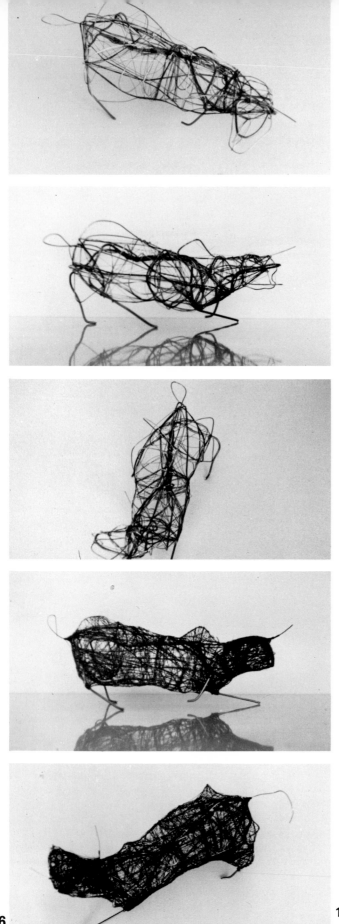

for something a bit more sophisticated. If permanence is desired, perhaps the work must be carried several steps past the quick sketch stage. Joints can be secured with wrapped wire, usually of a lighter weight, or adhesives can be used to keep joints from slipping and thereby adding greater rigidity. Bulk can be added by filling in voids with metal sheeting or screening, and securing these to the armature with bits of finer wire. Wood block bases can be used to provide insurance against tipping over. Such ideas and many more will be discussed on the following pages, but first consider tying wire joints together to obtain greater rigidity.

MATERIALS AND PROCEDURES

Developing a sculpture of greater complexity and stronger construction involves a basic skeletal armature as a beginning. The wire used for this framework should be the heaviest gauge used in the entire structure. It should be about as heavy as the student can work, and should be heavier in direct proportion to the size of the structure. This heavy form should be of one piece, if possible, as this adds greater strength, and it should contain the major turns and twists of the finished product.

In working with the heavy wire, while forming the basic structure and shape, tools will probably be needed. Needle-nosed pliers and other pliers are handy for the bending and twisting of wire around itself to secure ends and add firmness. Sometimes bench vises can be used for bending, or shapes can be bent over the edge of a bench, chair or table.

1

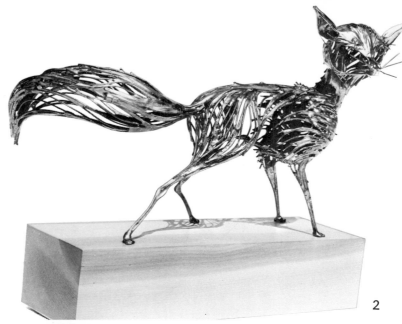

2

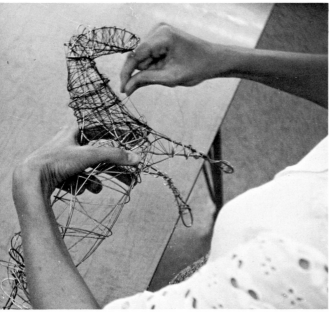

3

5

1. Cat figure uses several sizes and types of wire, but final wrapping is of 30 gauge copper wire.

2. "Fox" is welded wire sculpture by Russ Shears.

3. Horse is receiving a wrapping of fine wire prior to getting a liquid metal coating.

4. "Form #1" by Hugh Merry. Courtesy Orlando Gallery, Encino, California.

5. Fish structure is of 18 gauge wire twisted back and forth many times, and coated with liquid metal. Lutheran High School, Los Angeles.

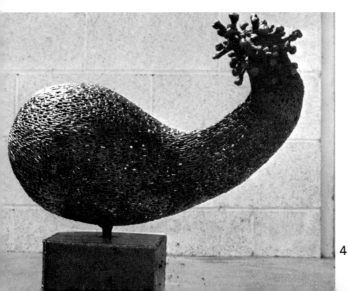

4

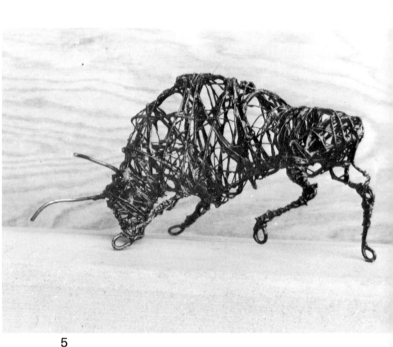

4 5

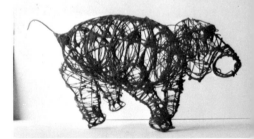

1. *Delicate praying mantis is given a spray coat of gold paint. Lutheran High School, Los Angeles.*

2. *Carefully soldered wire figure by student in Los Angeles City Schools System.*

3. *Open-mouthed hippo is of wire and liquid metal and painted dark gray. Lutheran High School, Los Angeles.*

4. *Crossing tower, Notre Dame Cathedral, Paris, France; courtesy Trans-World Airlines, Los Angeles, California.*

5. *Sturdy bull of wire and liquid metal is given a color coat of black and rubbed with dark brown casein. Lutheran High School, Los Angeles.*

6. *Romping elephant made delightful use of natural coils of the wire. Lutheran High School, Los Angeles.*

7. *"Signal Rocket" by Takis Vassilakis is of painted steel and iron. Collection, The Museum of Modern Art, New York. Mrs. Charles V. Hickox Fund.*

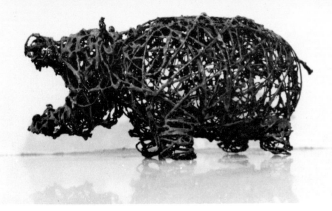

3

Very tight bends might require the use of two pairs of pliers or maybe even two pairs of hands.

It is helpful to spend substantial time on this basic stage of development regarding composition, movement, rhythm, and the anticipated outcome. However, it is better to allow the structure to develop and grow in our hands than to attempt to anticipate all problems and changes by sketching in detail first. Changes can be made later, but here is where the big movements of the sculpture are decided. At this stage, the sculpture appears to be very much like the quick sketch product at its conclusion. Wherever wires cross in this structure, or even come close together, they should be tied together with lighter weight wire that is softer and easier to work. A simple wrap-around of two or three loops is all that's necessary to begin to get greater rigidity. This should be done as often as possible at the early stages, because this underlying skeleton will be buried under more wrapping of wire and will be hard to get at in later stages of building.

Once this basic skeleton is structured, the wrapping process begins. Using wire of a lighter weight than the outline, but still about as heavy as can be worked at this stage, begin to develop the volume of the sculpture. This is done by coiling the wire around the torso as loosely or as tightly as desired, providing dimension to the extremities. developing a cocoon-like feeling in places and providing the beginning of larger details. Here again tools might be needed to work this weight of wire, especially in cases of sharp bends, and adhering this wire to the basic structure with a few deft twists. The resulting crossings of wire should now be tied with finer wire in as many places as needed to get the desired strength. Three weights of wire are usually sufficient for most sculpture.

This process continues, using lighter weight wires and tying to the foregoing structure as much as needed to give proper strength. Don't get over-

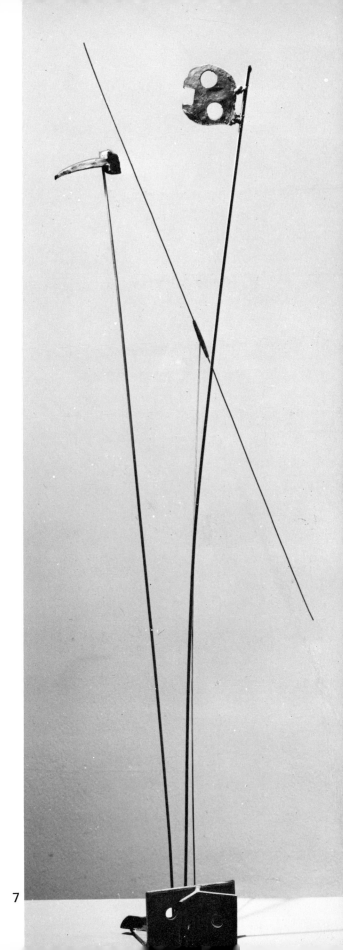

7

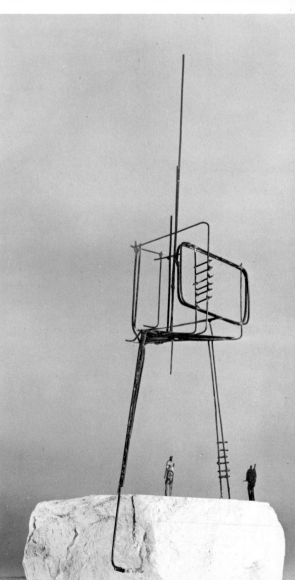

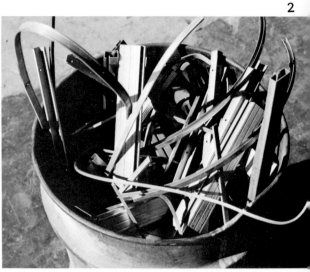

1. "Grass" by Len Lye is of stainless steel, and is motorized and programmed to start the grass swaying. Albright-Knox Art Gallery, Buffalo, New York.

2. Metal scrap bins like this are the beginning of many three dimensional constructions.

3. "The Unknown Political Prisoner" by Reg Butler. Collection, The Museum of Modern Art, New York. Saidie A. May Fund.

4. Seated figure is nearly two feet high and rests on beautiful found log. Lutheran High School, Los Angeles.

5. "U as a Set", by Claire Falkenstein is formed of arcs of copper tubing. Courtesy California State College at Long Beach.

6. Man carrying a barrel, liquid metal and wire. Lutheran High School, Los Angeles.

7. Sauntering figure is balanced to stand on one foot. Lutheran High School, Los Angeles.

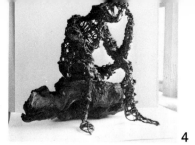

4

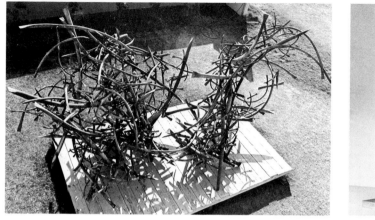

5

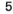

6

7

involved with the tying process, only enough to keep the shape firm and prevent slipping of major wires from their place. Keep in mind that changes in shape can be made at any point simply by giving a twist, or indenting with a shove. This might involve the retying of wires made slack by the change, but shouldn't hinder the improvement of the shape.

As finer wires are used, finer definition can be obtained, but keep in mind that fine detail is not a desired goal of wire sculpture. As the structure increases in strength, major changes in form are more difficult. These should be observed and carried out at an early stage in the development of the construction. Desired objectives are feelings of movement, evidence of the underlying structure, qualities of good design, over-all form, a wire-like structural feeling, and perhaps any personal goal of the artist.

A good expression to use at this stage of work is "openwork sculpture". Keep the work open enough to see the underlying structure. Look at gothic spires, The Eiffel Tower, Simon Rodia's towers in Watts, California, the rib cage of animals, the framing of a house. Keep in mind the element of surprise, so that at every change of point of viewing you can see *through* the sculpture to the other side. It's like the airframe of a jetliner, without the skin. If you look at its shadow in the sunlight, it's like a continuous line drawing. Like the shadow the winter trees make on the concrete walk.

When the structures have begun to occupy space

and develop a feeling of volume, the sculptor can begin to add adhesives or liquid metal to bind the wires permanently. Liquid metal can be applied with a stick, spatula, palette knife, a loop of wire, or thinned to apply with an old brush. All applying tools should be cleaned immediately after use if they are to be reused. Apply as much of this material as needed to get the required solidity of form and structure. Keep the openwork feeling in these particular pieces so the viewer's eye can wander *through* the sculpture as well as around it. After a thorough drying, the sculpture can be finished, painted, covered with a patina, and mounted. (See chapter on finishes for information and ideas.)

Look at the variety of examples visualized on these pages. There is no limit to the extent of ideas and subject matter workable in this medium. Work can be done in small scale or large. Successful pieces have been produced more than five feet in height.

OTHER IDEAS

What if wire is too stiff to bend properly, or what if you can pick up a roll of spring steel? You *can* throw it away, or you *can* make good use of it. Such hard and unmanageable wires can be used in harmony with softer wires, but they should be allowed to maintain their characteristic resiliency. Make a sculpture that will allow the springy parts to be "plucked" or "strummed". They might even make "music". Some of the visuals on these pages will provide ideas for using such stiff and resilient wire.

Copper tubing, large metal staples, preformed pieces, and other shapes that cannot be altered may be incorporated into delightful studies with a bit of imagination and some good adhesives.

Experiment with wires and adhesives, since your local area might produce or use types that are not available everywhere. Seek out local suppliers and see what's available. Surplus warehouses are often treasure troves of odd types of materials that are a boon to creative constructionists.

TYPICAL PROBLEM

Develop imaginary insect between eight and ten inches in longest dimension. Develop armature and wrap wire to produce volume. Tie wire crossings to produce rigid structure. Add one new material (such as screening, sheet metal, glass, etc.) to the work. Use liquid metal as the adhesive agent. Finish and mount.

WIRE SCULPTURE/AND SHEET METAL

Large flat areas that should be constructed as a solid shape are best built up by using sheet metal of some type. Beautiful combinations of flat shapes and stringy wire can be produced in this way. Heaviness and bulkiness can be incorporated if it is desired. Flat and twisted and flowing planes, unable to be produced with wire alone, are manageable.

MATERIALS

All types of flat metal sheeting are usable, depending on accessibility. Scrap galvanized sheeting is available from many tinsmiths, people who make rain gutters and downspouts. Old zinc and aluminum plates from offset lithographers are wonderful and easy to cut and use. Some shapes of copper can be bought in hobby shops. Aluminum foil or cardboard can be used and coated with liquid metal. Again, local facilities might produce a readily usable and available product—check and see.

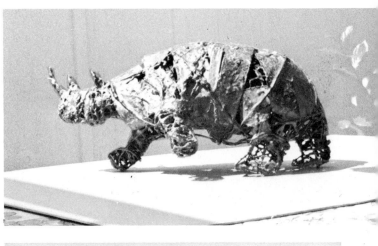

1

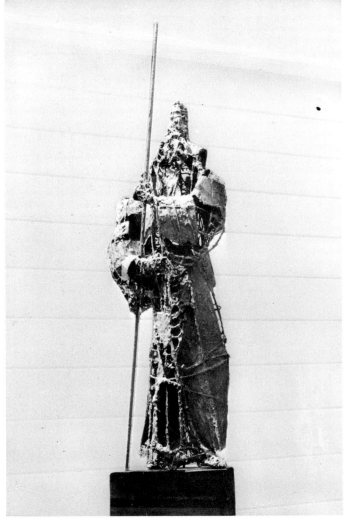

2

1. Tank-like body of this rhinoceros is built of sheet metal strips over wire form. By the author.

2. Towering four-foot wire sculpture of St. Peter is of wire, chicken wire and sheet metal. By the author.

3. "Starburst" is sheet metal leafed in gold and silver by William Bowie. Courtesy The Sculpture Studio, New York.

4. "Compatibility" is of sheet metal alone with no wire parts. By Reinhold Marxhausen.

5. Flowing mane of this graceful horse is of sheet metal. Lutheran High School, Los Angeles.

6. Part of the knight's armor is of sheet metal, while his lance is of coathanger wire. Figure is painted black. Lutheran High School, Los Angeles.

7. Welded rods formed this exquisite mountain goat by Russ Shears.

3

4

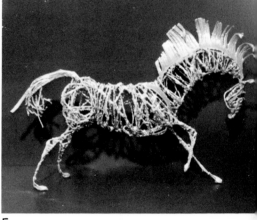

5

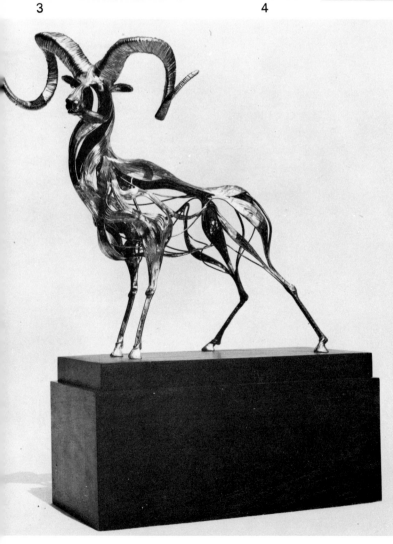

7

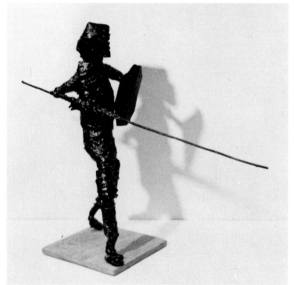

6

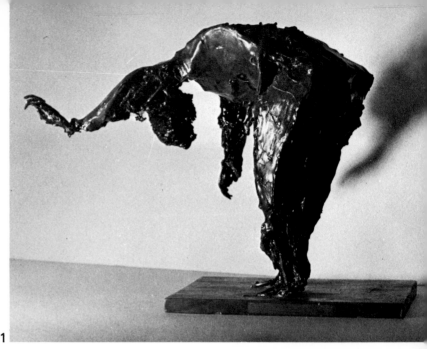

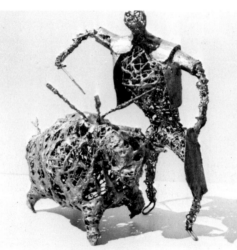

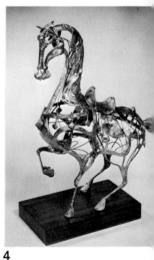

1. *Bowing figure has much sheet metal over which liquid metal was applied. The enamel-painted figure is from Lutheran High School, Los Angeles.*

2. *Bull fighting sequence is of wire and sheet metal sprayed with metallic paint. Lutheran High School, Los Angeles.*

3. *"Reflections" by William Bowie. Courtesy the American Craftsmen's Council, New York.*

4. *Prancing horse is by Russ Shears.*

5. *"Crown of Thorns" by the author, is of sheet metal and 12 gauge wire, and is sprayed with bronze paint and given a dark patina.*

6. *Charging bull is by Russ Shears.*

7. *"St. George and the Dragon", by the author, has sheet metal in both figures. Red patina was applied over black spray paint.*

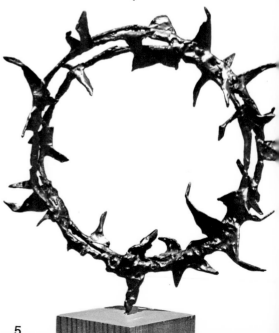

5

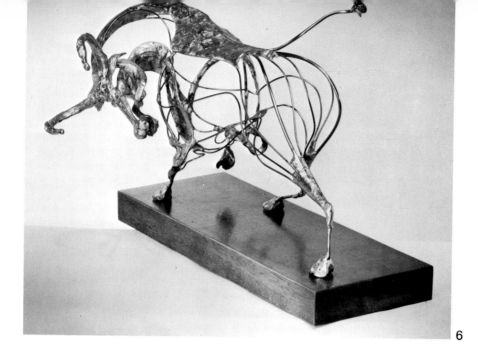

6

PROCEDURES

When the wire armature and the next series of wire applications is completed, and the tying has produced a rigid shape, the flat metal parts are ready to be added.

Cut the pieces to fit, perhaps using a paper shape as a pattern. A fold of the sheet around a strong part of the armature will anchor it securely. Perhaps a tab, like those on paper doll clothes, is the best solution to the initial adhering of shape to armature. Wires can run over the flat piece to hold it in place until liquid metal or other adhesives lock it permanently.

Textures can be built up on the metal sheets with liquid metal or they can be left smooth. Care should be taken to securely tie the shaped metal to the form, and then with adhesives anchor it firmly, building up the joint area with the adhesive to appear like a firm weld. Some sculpture might be predominately sheet metal and others might use it only for an accent.

Finishes, patinas, rubbings, and mountings are very important to concluding the work. (See chapter on finishes for ideas.)

OTHER IDEAS

Look at welded metal sculptures in museums, galleries, and art magazines for ideas. Complete welded work cannot be adapted, but some shapes and ideas are applicable. Try a wall mounted form rather than a table oriented sculpture.

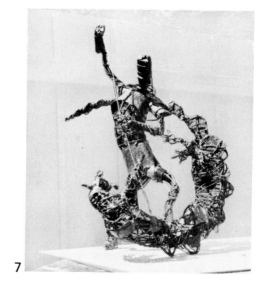

7

Use sets of similar pre-cut shapes in making a structure. For example, cut a metal sheet into squares or U-shaped pieces. Bend them slightly and incorporate them into the wire structure. Perhaps a geometrical structure would work well here—with architectural overtones.

When texturing the liquid metal-covered flat areas add foreign materials like sand, gravel, iron filings, washers, paper clips, staples or other pre-cut material that will suit the sculpture. Before the liquid has set firmly, lines and textural marks can be scratched into the surface.

TYPICAL PROBLEM

Produce wire sculpture of large and cumbersome mammal such as a rhinoceros, elephant, alligator, etc. Size not to exceed 20 inches in longest dimension. Add sheet metal of some type to the structure to show mass and weight. Use liquid metal as adhesive agent. Texture, paint, patina, and mount.

WIRE SCULPTURE/
ADD GLASS OR ENAMELED METAL

A splash of color, a bit of light, and a new product is born. Change in feeling and visual excitement are the result of adding glass or brightly enameled or painted pieces to a wire sculpture. Of course, such addition should not be made unless the sculpture is enhanced by it, but in most cases, the addition of color is an important ingredient in the work. If the finished product will be placed in front of a window, the use of stained glass, either sheet or chunk, is an exciting touch.

MATERIALS

It is possible that the sculpture might make use of glass as the predominate ingredient, and the wire might serve only as a foil. If chunk glass is available, it is a wonderfully bright and stimulating material.

Sheet glass in a variety of colors and textures is available at most glass suppliers. Scrap can be obtained free, if a visit can be made occasionally to pick it up.

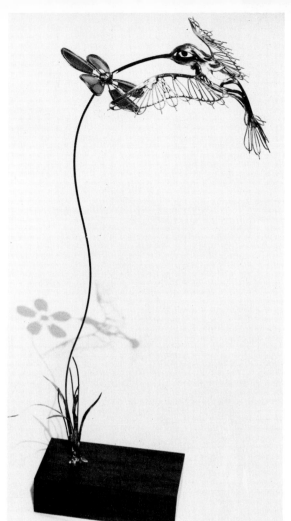

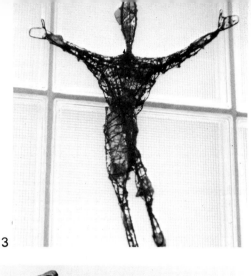

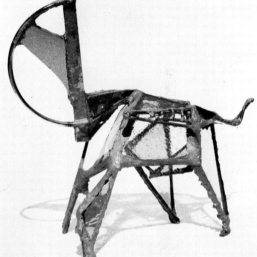

1. "Man Alone", brass and stained glass by Eva Cossock. Courtesy American Craftsmen's Council, New York.

2. "Hummingbird", steel and enameled parts by Russ Shears.

3. "Rising Figure", wire and stained glass, by the author.

4. Glass and steel animal, by Eva Cossock.

5. "Peacock Chimes", wire and copper coated steel, by William Bowie; courtesy The Sculpture Studio, Inc., New York.

6. Strutting rooster is of wire and liquid metal and has red drinking glass chunks inserted to add color. Lutheran High School, Los Angeles.

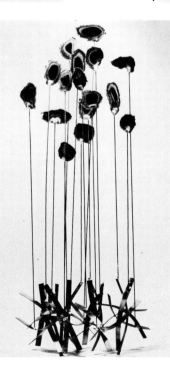

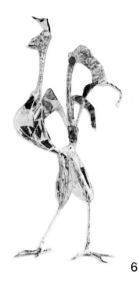

1. Glass and steel structure by Eva Cossock.

2. Enamel and metal composition, Granada Hills High School, Granada Hills, California. (Los Angeles City Schools)

3. "Spatial Kaleidoscope", motorized steel and stained glass by Roger Darricarrere; courtesy American Craftsmen's Council, New York.

4. Wire, steel and enamel by Russ Shears.

5. Brass and glass structure by Eva Cossock.

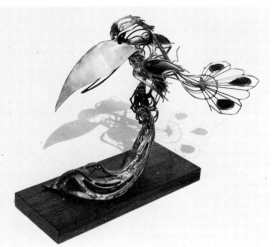

4

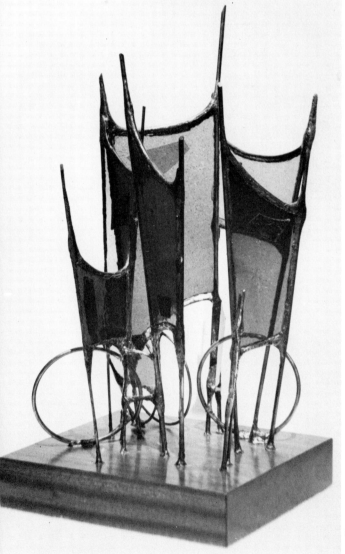

5

PROCEDURES

Addition of glass to a wire sculpture is accomplished near the end of the building so that the material can be kept as clean as possible. The colored material should be placed into position and can be caged with wire to hold it in place.

If available, channeled lead material, used in making stained glass windows, can be purchased and used in the sculpture, if desired. Liquid metal will hold wire and glass in place also, but the central part of the glass should be covered during work with a material like petroleum jelly or masking tape, to prevent sticking of the adhesive material. A heavy coat of tempera paint will also work, to be washed off when the sculpture is finished. Experimentation will provide many answers as to how the glass may be used.

Enameled parts will also add splashes of color. Perhaps a bird's wings or a flower's petals might be enameled. Acrylic painted metal might also be used for this purpose.

OTHER IDEAS

Stiff wire or welding rods can support a field of glass or enamel shapes, and make an exciting arrangement.

When sheet glass or chunk glass is unavailable, use broken bottle glass or pieces of old drinking glasses. Plain clear glass can also be painted with Prang DekAll paint; or acrylic paints can give a stained glass appearance. Generally speaking, the addition of glass or enameled parts would be for accent only, and therefore used sparingly. However, these

1

2

additional materials might well become a very strong part of the work.

Develop a wooden scrap box for glass pieces and have students add to the supply.

Glass can either be cut with a glass cutter (if exact shapes are desired) or can be broken down by placing in a cloth sack or under a heavy cloth, and striking with a hammer. Glass structures can be built using sculpmetal as an adhesive agent. The resulting sculpture will look as though the glass is leaded together. Hold glass in place with rubber bands or string until the sculpmetal has dried.

TYPICAL PROBLEM
Construct a wire sculpture design, not more than 12 inches in its longest dimension. Add bits of colored glass as accent to the sculpture. These should be held in place by liquid metal. Choose a subject for the sculpture that can make appropriate use of the added color.

WIRE SCULPTURE/OTHER ADHESIVES
Experimentation is a key word in wire sculpture, and no teacher or class should be satisfied that the

ideas this book illustrates are the last words to be written concerning this exciting art form. There is no need to scrub openwork wire sculpture if your budget can't stand the purchase of the liquid aluminum adhesives. Many other materials, although not allowing the bulk that sculpmetal or resins provide, are still stimulating and acceptable, and produce permanent sculptures.

MATERIALS
Such experimental adhesives may include tubed plastic aluminum, plastic steel, liquid solder, mastics of various types, resins, and the like. Hardware store shelves abound in a variety of plastic adhesives that can be tried. White vinyl glue is a very acceptable adhesive, but the structure must first be made very soundly, as the glue is not capable of holding large wires in place.

In all work illustrated on these pages, the pieces are rather small and the wire is closely wrapped. Armature wire should be heavy enough to keep the shape even after completion, and lots of very fine wire is used in the wrapping process. Unwound electric armature wire or 30 gauge steel is excellent for this.

3

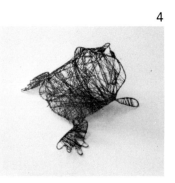

4

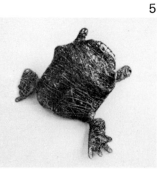

5

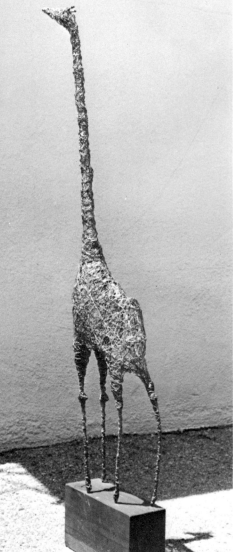

6

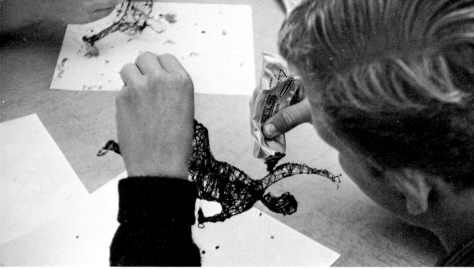

8

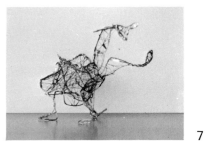

7

1. *Adding plastic aluminum from tube to small wire figure.*
2. *"Lobster", wire and white vinyl glue with casein paint by the author; courtesy Dr. and Mrs. John S. Hough, Malibu, California.*
3. *"Goat", wire and white vinyl glue, painted with casein, by the author.*
4, 5. *Frog shown in stages of development, the second wrapped more completely than the first. White vinyl glue is the adhesive material used. Frog is spray painted and has a casein patina.*
6. *Wire and white vinyl glue, left unpainted, by Warren Ostrus.*
7. *Wirey walking figure of wire and white vinyl glue, Lutheran High School, Los Angeles.*
8. *Applying black liquid steel from tube to wire figure.*

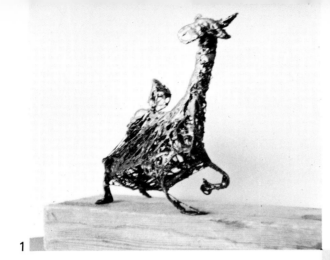

1

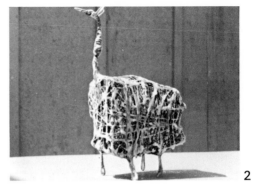

2

3

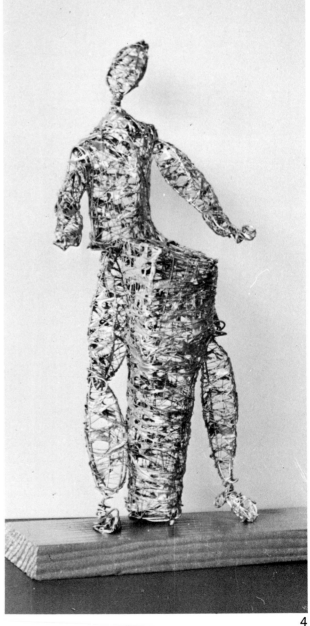

4

1. *Wire and liquid solder, spray painted, Lutheran High School, Los Angeles.*

2. *"Llama", wire and white vinyl glue, painted with casein, by the author.*

3. *"Dove", wire, sheet metal and plastic resin by the author. Courtesy Daystar Designs, Inc., Van Nuys, Calif.*

4. *Wire and liquid solder, spray painted, Lutheran High School, Los Angeles.*

5. *Applying liquid solder from squeeze tube.*

6. *"Seated Figure", wire and white vinyl glue with casein paint by the author.*

7. *Very fine wire used as wrapping in this bull figure. Adhesive is white vinyl glue.*

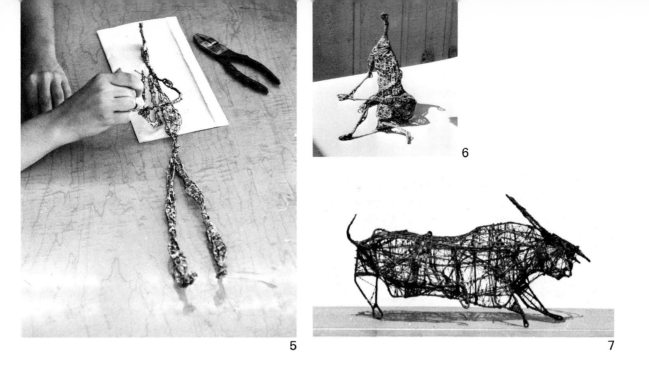

5

6

7

PROCEDURE

After selecting subject matter, bend the wire form to show all major protrusions and indentations. Use the heaviest wire that is convenient with the size of the sculpture. Tie these wires to each other with the fine wire as often as needed to produce a rigid shape. Use the same heavy wire to give volume to the form, because the very fine wrapping wire will not give shape itself, it will only form a cocoon-like structure around the armature form.

When the sculptural form has been delineated with the heavy and medium wires, the wrapping process can begin. Using very fine but pliable wire, usually of copper, begin wrapping, tying, and looping to form the volume. From time to time, coats of vinyl glue should be brushed over the developing structure or if other adhesives are used, they can be applied as necessary.

The vinyl glue is not extremely strong in this type of application, but by wrapping and gluing and building up thickness after many brushings, a surprising rigidity develops.

Because of a lack of ability to fill in spaces with the vinyl glue, the sculpture will have a fine delicate and wire-like appearance.

Allow sufficient drying time between all applications of any material. When the sculpture "feels" finished it can be painted and mounted as described in the chapter on finishing.

OTHER IDEAS

If vinyl glue is too "runny", exposure to air will thicken it so it will cover sculpture in a quicker way. Drops of glue that drip through the sculpture can be picked up with the brush and re-applied to the structure.

If fine wrapping wire tends to slide off the rounded armature wires, a coat of glue, when dry, will add traction to prevent slipping.

The more coats of glue applied, the more sturdy the structure becomes.

The white glue dries clear, but it is possible to put tempera in it to provide color, or else the whole structure can be sprayed after completion.

Size should be kept below 15 inches, due to the amount of fine wire wrapping that is necessary. Size isn't a limiting factor (some of this type have been three feet in length), but time might well limit the size. Experiment with some of the resins that are available in plastic specialty stores or surfboard supply houses. Mixing the hardener and the base material, which when placed on, in, over, or around the wire sculpture, can be sawed, filed, or cut. It can be colored before application, or painted later. It should produce sculptures similar in construction to those made with sculpmetal, only stronger.

1

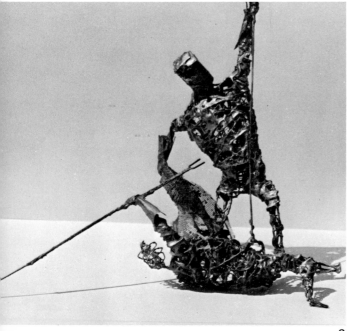

2

TYPICAL PROBLEM

Construct a four-legged animal in action, with three feet on the ground. Use white vinyl glue as adhesive and keep entire sculpture under ten inches in longest dimension. Sculpture must be free standing. Paint and finish.

WIRE SCULPTURE/ADD OTHER MATERIALS

Don't throw away any metal scraps or parts! All of it will end up sooner or later in a wire sculpture, if you have a scrap box that is handy for students to rummage through. It is in the selection of materials and the appropriateness of their application that the individual can express himself. Merely provide a box, get the students to contribute to it, and allow them to take from it as they find the need.

MATERIALS

All types of scrap metal contribute to the effectiveness of the project. Metal screen, hardware cloth (a wire mesh), metal lathing, chicken wire, fencing, scraps of sheet metal, preformed metal parts, gears, nuts and bolts, nails, screws, washers, and clock workings are only several of the kind of things that can occupy the scrap box for a while. Together with such metal parts, papers and cardboards can be integrated into the sculptures, as can a variety of metal household foils.

String or nylon threads can also be incorporated into the wire designs. The variety of experiments is almost endless, and is merely limited by time for experimentation.

PROCEDURES

Gluing and wrapping are the principal methods of adhering these new materials to the wire structure. Trial and error will provide the best knowledge as to what adhesive will hold each material in place. Airplane glue will hold tissue paper and string. Sculpmetal and wire wrapping will hold screening and sheet metals. Vinyl glue will hold nuts and bolts and washers.

TYPICAL PROBLEM

Create a bird or insect form of wire, adding two other materials to the sculpture (for example screen and washers). Leave choice of materials open. Use sculpmetal and/or other appropriate adhesives. Keep under 15 inches in longest dimension. Finish and mount.

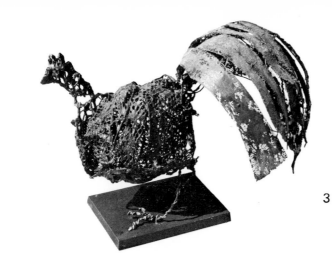

3

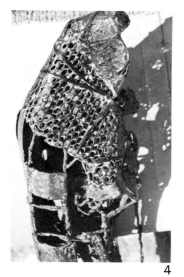

4

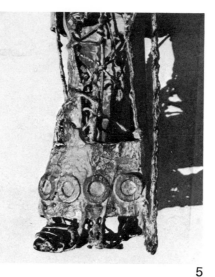

5

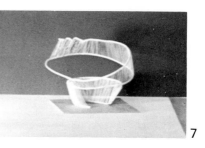

6

7

8

1. *Wire and colored tissue paper tower structure, Le Conte Junior High School, Hollywood. (Los Angeles City Schools)*

2. *Wire, sculpmetal and wire mesh, Lutheran High School, Los Angeles, California.*

3. *Wire, metal lath, aluminum screen and sculpmetal; Lutheran High School, Los Angeles, California.*

4. *Metal lath covered with sculpmetal forms a textured part of this wire sculpture. Figure is spray painted black and given a bluish patina with casein paint.*

5. *Detail of sculpture of wire, sheet metal and metal washers. Sculpmetal is the binding agent.*

6. *Wire with metal washers and other found metal parts, Lutheran High School, Los Angeles, California.*

7. *Wire and string; Lutheran High School, Los Angeles, California.*

8. *"Metamorphosis (Heraldry)", relief of wire mesh and wire on painted wood, by Manuel Rivera; Collection, The Museum of Modern Art, New York, gift of Mr. and Mrs. Richard Rodgers.*

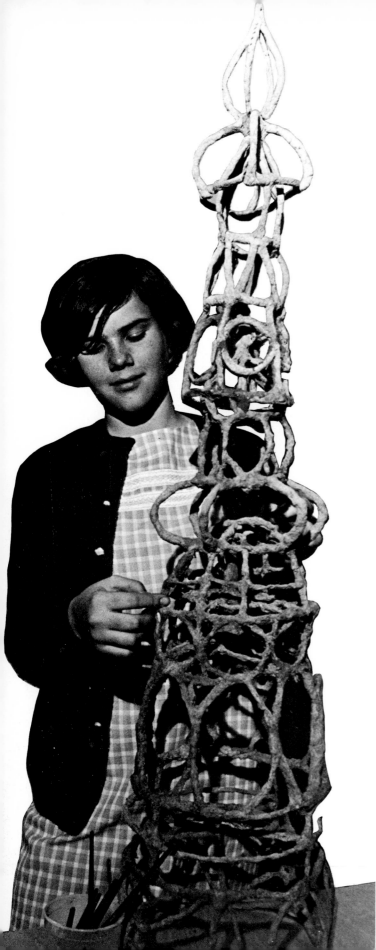

2

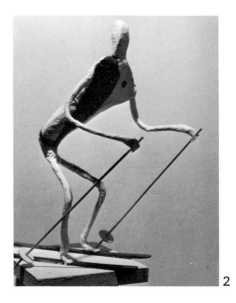

WIRE SCULPTURE/ADD PAPIER-MÂCHÉ

''Build a wiry tower out of papier-mâché?''

''Impossible!''

Don't be so sure. With a wire armature it is not an impossible task to accomplish. In fact, it is pretty exciting.

MATERIALS

Wire bound together into a strong and rigid form will provide the basic armature for the structure. The papier-mâché can be of any of a variety of prepared mixes or the wheat-paste variety. Paper strips will form the outer coating and provide a paintable surface.

PROCEDURES

In both the towers and the figures illustrated, the wire armature was formed first. Heavy wire is used or a lighter wire reinforced by wrapping a like wire around it and twisting. Joints are securely wired together to prevent weaknesses in the structure.

After making sure of major bends, loops, and forms, the papier-mâché can be applied. The prepared mixes or the wheat-paste variety can be applied and squeezed into place and shape, building up the forms to a desired thickness. Facial tissue, soaked

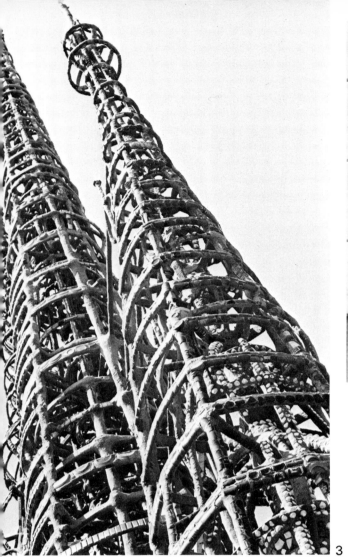

3

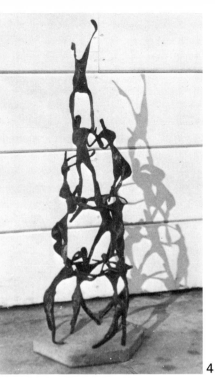

4

5

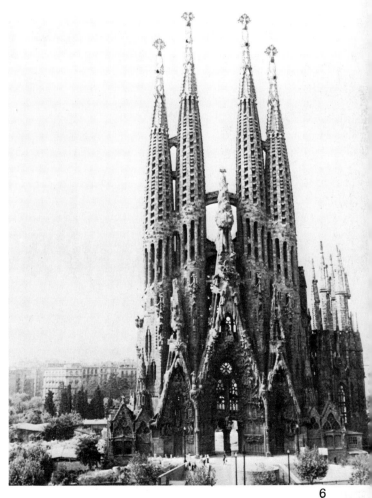

6

1. *Wire and papier-mâché tower structure; Le Conte Junior High School, Hollywood, California. (Los Angeles City Schools)*

2. *Wire and papier-mâché; Northridge Junior High School, Northridge, California (Los Angeles City Schools)*

3. *Simon Rodia's Towers in Watts, California, seem to be made of wire and papier-mâché, but in reality are steel, cement, and a myriad of found objects.*

4. *"Pyramid", wire and papier-mâché with tissue coating, by Richard Wiegmann.*

5. *Wire, papier-mâché and string, Northridge Junior High School, Northridge, California. (Los Angeles City Schools).*

6. *Temple of the Holy Family, Barcelona, Spain, designed by Antonio Gaudi; courtesy Ministerio de Informacion y Turismo.*

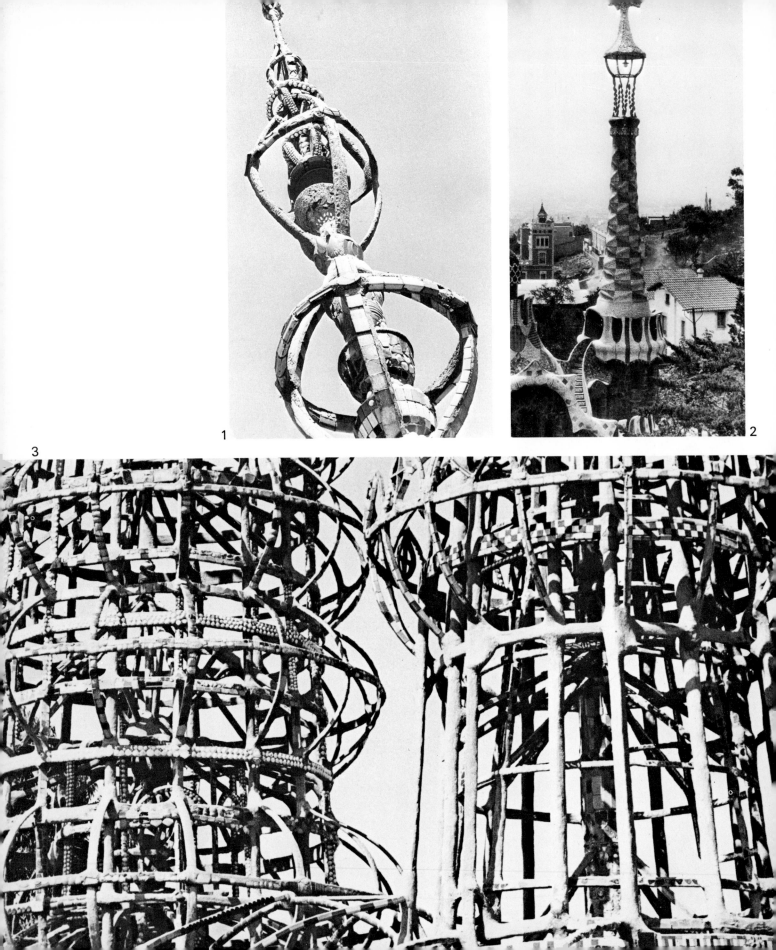

1

2

3

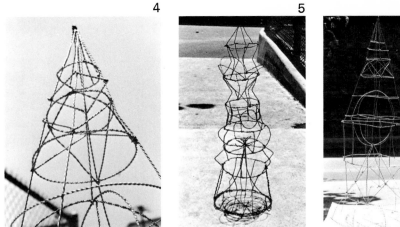

4 5 6

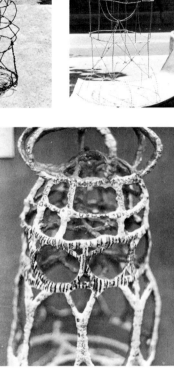

7

8

1. *One of many decorative capitals topping Simon Rodia's Towers in Watts, California.*

2. *Tower in Parque de Guell, Barcelona, Spain, designed by Antonio Gaudi; courtesy Ministerio de Informacion y Turismo.*

3. *Detail of the base of Simon Rodia's Towers, Watts, California.*

4, 5, 6. *Twisted wire armatures for papier-mâché towers; Le Conte Junior High School, Hollywood, California. (Los Angeles City Schools)*

7. *Detail of wire and papier-mâché tower structure, painted and decorated; Le Conte Junior High School, Hollywood, California. (Los Angeles City Schools)*

8. *Wire and papier-mâché tower; Le Conte Junior High School, Hollywood, California. (Los Angeles City Schools)*

in wheat-paste, can be wrapped around the wires and gradually built up to final form, if prepared materials are not available. Following any of these operations, the final covering is applied by dipping strips of newspaper, newsprint, or paper toweling into wheat paste and wrapping it around the complete area of the sculpture. Special attention and application should be made to all joints to help in making them firm and solid.

After thorough drying, the figure or tower can be decorated. Tempera paints, acrylic paints, or colored tissue paper can enhance the sculpture and produce a finish the artist desires. Following decoration, the entire sculpture can be given a coat of clear shellac to preserve it and protect it from mildew and soiling.

OTHER IDEAS

Emphasize figures or structures with very thin parts, since the wirelike quality should be visible in the finished structure. Here is a good chance to work on thin-legged antelope, or colts, or bean-pole people, or very thin structures that students usually try to work out in a less compatible medium. Before working on a tower unit, spend a day or more studying towers and their appearances and construction. This will stimulate thinking and the ensuing procedure of building. Use slides, magazine reproductions, or architectural films to motivate and inspire.

Illustrations show the Simon Rodia Towers in Watts, California, and some junior high school adaptations inspired by them.

TYPICAL PROBLEM

Design tower to be used as a symbol for an amusement park. Keep it wiry and bright in color. Make several sketches to give direction to your planning, and make it unusual and exciting. Cover wire armature with any type of papier-mâché and dec-

orate in bright and vivid colors. Tower should be free standing, and must be taller than two feet but less than four feet in height.

WIRE SCULPTURE/ ADD PLASTER OF PARIS

Addition of plaster of Paris to a wire sculpture can result in a variety of outcomes — solid figures, stringy shapes, or any range of sculpture in between. But in most cases, the "feel" of the finished product is not so much a wire form as it is a plaster sculpture. The addition of plaster is the quickest method of filling in voids and producing a solid structure. But if the finished product is to retain some of its wiry quality, the plaster must be applied with restraint.

MATERIALS

The basic figure is done in the same fashion as previous wire sculptures, but such great care in tying major wires together need not be taken, because the plaster will hold everything in shape, unless applied too thinly. Plaster of Paris, prepared in any of the familiar ways, is needed, and perhaps some cloth strips to build up areas quickly are desired. This depends on the desired effect. Pans, cans, and/or buckets are needed for mixing the plaster with water.

PROCEDURES

Basic wire shapes are required, but may vary in form. They can be balled wire figures, openwork sculptures or wire armatures with enough form to make the addition of cloth and plaster produce volume.

If a sort of balled wire form is used as a base, the plaster can be poured over the figure, adding layer upon layer until the desired effect is achieved. Pour over a bucket, because early in the procedure, most of the plaster will fall through the sculpture. Drips

that form can be broken off when dry and sanded smooth. The resulting finished work can be coated with shellac and then painted to prevent the rusting of wires. Or the wires can be sprayed with lacquer before the plaster is applied, and this also will prevent rusting and discoloration.

Another method of working with plaster involves a basic armature, around which plaster-dipped cloth strips are wrapped. The form can be made quite solid, or left open in places, but the strips will make a cocoon-like skin, which when dry can be built upon with more plaster. General shapes can be developed this way, and details either added with dabs of plaster, or subtracted by carving, shaving, or sanding. Steel brushes are best for this, but knives, hacksaw blades or other tools that can be cleaned easily are very useful. Plaster is best added with the help of spatula, palette knife, or spoon, but can also be brushed on while in a thin condition.

Again the finished and thoroughly dry sculptures can be shellacked, painted, and given a patina, if desired. It is best to mount plaster figures on a wood base to prevent chipping of parts when bumped, moved or set down.

OTHER IDEAS

If much carving is to be done on the plaster and wire figures using cloth strips, be sure that the coating of pure plaster is at least ¼ inch thick. If this is not watched, the cloth will appear in places and might even tear while finishing, and perhaps destroy the desired appearance.

Interesting textures can be developed with the addition of sand, ground plastic, sawdust, or some such materials to the plaster while mixing. Repeated stirrings are essential to keep texture material in suspension. When adding wet plaster to the already dry sculpture (if this is necessary) the sculpture

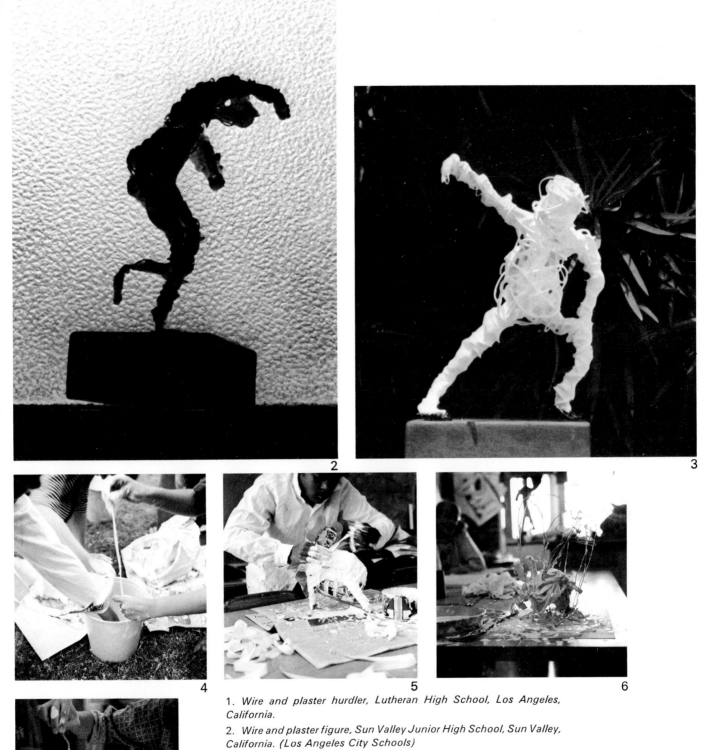

1. *Wire and plaster hurdler, Lutheran High School, Los Angeles, California.*

2. *Wire and plaster figure, Sun Valley Junior High School, Sun Valley, California. (Los Angeles City Schools)*

3. *Wire and plaster figure, Sun Valley Junior High School, Sun Valley, California. (Los Angeles City Schools)*

4. *Dipping cloth strips in plaster bucket.*

5. *Applying plaster strips to wire and paper armature.*

6. *Wire armature with initial application of plaster dipped cloth strips.*

7. *Adding plaster with palette knife.*

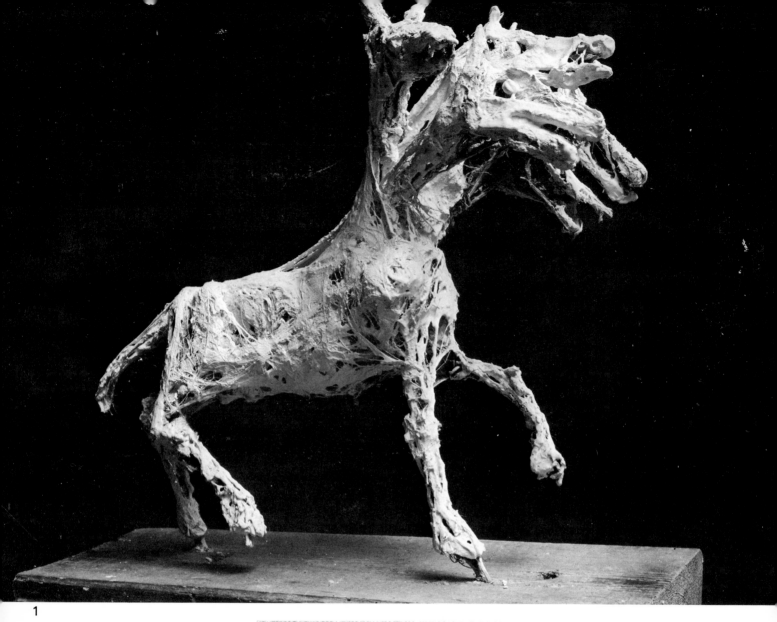

1

2

1. *"Six-headed Horse" plaster over string and wire, by Germaine Richier; Collection, The Museum of Modern Art, New York, gift of Mrs. Katharine Kuh.*

2. *Wire and plaster surfer, Sun Valley Junior High School, Sun Valley, California. (Los Angeles City Schools)*

3. *Incomplete figure using wire, paper and plaster, Lutheran High School, Los Angeles, California.*

4. *Wire, cloth and plaster sculpture by Roland Sylwester.*

5. *Wire and plaster skier, Sun Valley Junior High School, Sun Valley, California. (Los Angeles City Schools)*

should be dampened with a sponge or brush before applying.

If you don't have a favorite recipe for plaster of Paris, try putting water into the mixing bucket or can and sift handfuls of powered plaster onto the surface. Keep doing this until a small mound of plaster won't settle into the mixture. Stir with your hand to dissolve lumps, if there are any. And judge its thickness. It should be like thickened soup or sauce.

It is best to have several students work from the same mixing bucket, because once the plaster begins to set up in the pail, it must be disposed of in a hurry.

Disposable paint buckets are best to mix plaster in. They will last several days, if cleaned well, and then can be discarded. Try using paper strips to dip into plaster instead of the cloth ones described above.

TYPICAL PROBLEM

Make armature of wire human figure in some action sport, either in true proportions or abstracted to any degree desired. Cover with plaster and cloth strips. Add plaster to get desired effect. Figure should not exceed 18 inches in longest dimension. Shellac, paint, finish, and mount.

WIRE SCULPTURE/
TEXTURES AND FINISHES (FINISHING)

Remember the importance of the tactile sense that was mentioned earlier in the book? How the "feel" of the sculpture is important? The big shapes and large movements and forms are vital, but it often is the local texture—the relief characteristics in a certain area—that the hands read. And it is therefore essential that the finished work have an appealing textural quality.

Large chunks of heavy texture are not the whole story, neither would be an entire structure of equally smooth surfaces. These qualities might be used for special effects, and therefore used on an entire sculpture, but generally it is a combination of various textures that excites the tactile senses. A smooth area becomes more smooth if placed next to a rough region, and vice versa. Michelangelo's acute sense of taste caused many of his sculptures to be partly polished and partly rough. And in this was their peculiar quality of strength.

Look around you at all kinds of textures: ceramic, plaster, welded steel, massed leaves, a handful of sand, polished stainless steel. These can't all be copied directly onto a wire sculpture figure, but the *idea* of well prepared textures is easily adapted to several wire sculpture techniques. Look around! Ideas are there for the borrowing and adapting.

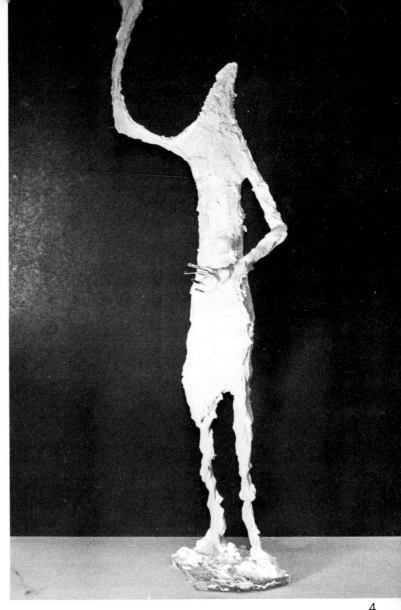

4

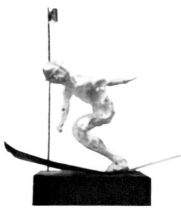

5

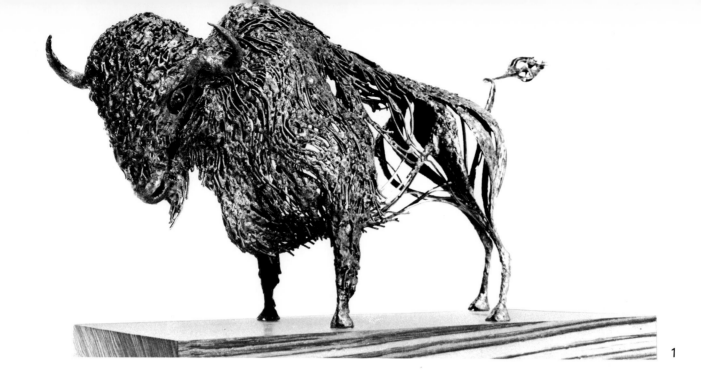

1

2

MATERIALS

Here is where a visit to the scrap bin might prove beneficial. Bunched up wire, screen, hardware cloth, metal lath, nails, sand, iron filings, washers, and all types of scrap may add delightful textures. The textural treatment of liquid metal, glues, or modeling pastes will also provide surface relief.

PROCEDURES

All types of scrap materials can be glued to the surface of the sculpture with epoxy or white vinyl glues. Liquid metal will also hold most scrap in place. Coarse textured screening can be wired in place and sand can be added to vinyl glue to provide small gritty textures.

Keep a variety in the sculptural surfaces—some areas smoother, some more heavily textured—but always make the textures in keeping with the emphasis of the subject. For example, a rhinoceros can have a surface almost like a tank in its hardness and armor-like quality. A lamb will have a much softer and wool-like feel, and the patterned texture of an alligator will be still different. Interesting

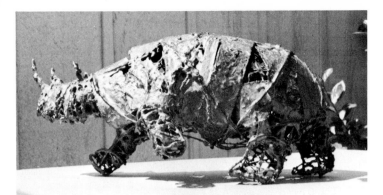

1. "Bison", welded steel with beautifully textured surfaces. Sculpture by Russ Shears.

2. "Landscape", textured stoneware surface by Dextra Frankel, courtesy American Craftsmen's Council, New York.

3. Textured sculpmetal on wire and sheet metal rhinoceros. Sculpture by the author.

4. Detail of sculpture using wire and metal washers to create a dragon texture. Sculpture by Warren Ostrus.

5. Detail of wire and sheet metal sculpture using sculpmetal textured for surface treatment.

6. Detail of sculpture showing textured surface using metal lath and sculpmetal. Patina emphasizes textural treatment.

3

4 5 6

textures can be made by scratching and drawing with a stick in the unhardened surfaces of modeling paste, sculpmetal, or white glue. Apply a coat of the material to an area and when it begins to set up, work designs or scribbles into the surface with a stick or piece of wire.

Sand can be sprinkled on a coat of white glue and when firmly set, covered with another coat of glue. If the sculpture will remain unpainted, the sand will remain visible, but if the sculpture gets a coat or two of paint, only the textural surfaces will be felt, only the texture of the sand piercing an otherwise smooth surface.

COLOR, PATINA, FINISHES

Three-dimensional figures, regardless of their textural variety and excellence, still need an appropriate finish to appeal to the eye as well as the touch. The large forms, the flow of the curves, the variety of indentations and protrusions, the exciting textural surfaces are all very important. But of equal importance is the final touch—the color and the finish. These help attract the viewer and lure him closer

until he can touch and feel the total sculpture and be affected by it.

The variety of finishes is only limited by the number of people experimenting and the time allowed for this final touch. Painting, rubbing, polishing, stippling, spraying, collaging, wiping, and applying a patina are some methods that might be employed. But in providing the proper finish, the color and type of paint must be considered an integral part of the sculpture.

Where will it stand?
Does it need bright or subtle color?
Does it require a patina or not?
Should it look metallic or organic?
Should the texture be emphasized or played down?

The color and finish are the crowning touch and shouldn't be handled indifferently. It is an important phase of the construction.

MATERIALS

A variety of materials can be used and not all will be listed here. Again, experimentation, local resources

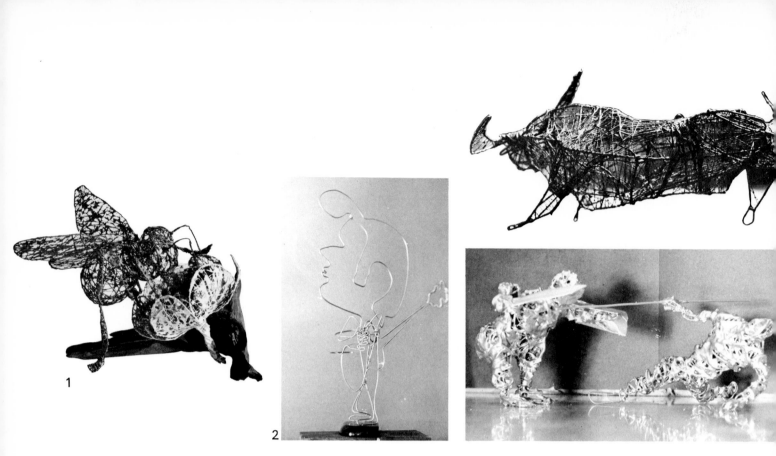

1

2

and individual curiosity will provide numerous solutions.

Openwork wire sculpture is most easily painted by spraying with aerosol-powered paint. A choice must be made as to color, metallic quality, and desired effect. Wrought iron paint, copper, brass, and gold sprays all provide a raw metal color that can be treated with a patina. It is difficult to brush color onto wire sculptures because of the complex network of overlapping wires. Spray cans are a fine answer. Use lots of paper to protect the surroundings from a similar coat of paint.

Patinas can be added to painted surfaces with casein paints or with prepared patina mixtures available in hardware or art supply stores.

PROCEDURES

One example will be provided from which numerous adaptions can be made. The desired effect is one of true metal, but with an old and textured appearance!

The wire sculpture is first covered with a brushed coat of white vinyl glue which smooths the sharp and rough edges and points that might otherwise tear material or cut fingers. This step might be eliminated, or two coats might be required, depending on the condition of the surface.

Following thorough drying, the sculpture is given two spray coats of gray metal primer, the kind used on automobiles. When these are completely dry, a coat of off-white casein paint, watered down to a

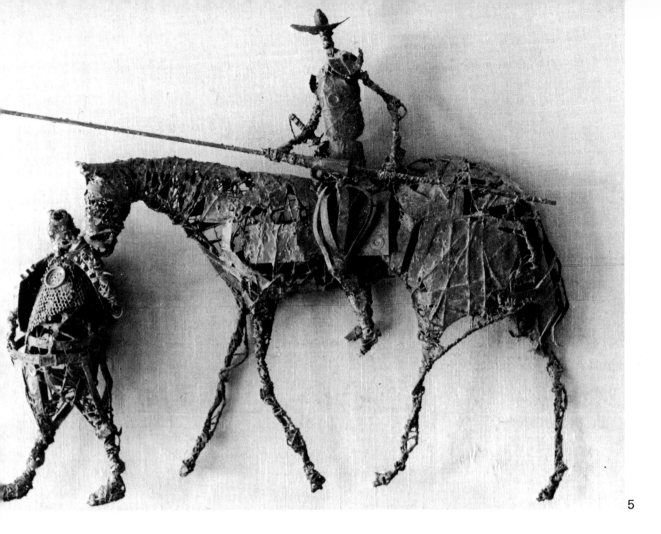

consistency of whole milk, is brushed on the sculpture. This casein might be tinted red, green, blue or any other direction desired. While still wet, this is rubbed with a dry cloth to remove most of the casein, but leaving enough to emphasize textures and a patina effect. If the casein dries before wiping, dampen the rubbing cloth a bit to help remove some of the paint.

After a day, the whole sculpture can receive a light buffing to make some parts shine while others remain dull and colored by casein. The finish is done, and the sculpture is ready for mounting, if necessary.

OTHER IDEAS

Tempera or casein colors can be added to the coat of white glue to provide additional color. Care is

1. *Huge but delicate bee is painted with gold metallic paint, and has no patina. It was later placed on mammoth wire flower painted white. Driftwood base was added for stability. Lutheran High School Los Angeles, California.*

2. *Wire formed guitar player is of aluminum wire, and needs no finish at all. Lutheran High School, Los Angeles, California.*

3. *Water buffalo sculpture of wire and white vinyl glue has a spray paint of flat black with no patina. Sculpture by the author.*

4. *Fighting figures of wire and sculpmetal have a coat of metallic copper spray. Lutheran High School, Los Angeles, California.*

5. *"Don Quixote", a large wire sculpture with sheet metal and found aluminum parts, adhered with sculpmetal. Painted with dark gray metal primer and given a light gray patina with casein paint. Sculpture, by the author is nearly five feet in width and is wall mounted. Courtesy Dr. and Mrs. Theodore Labrenz.*

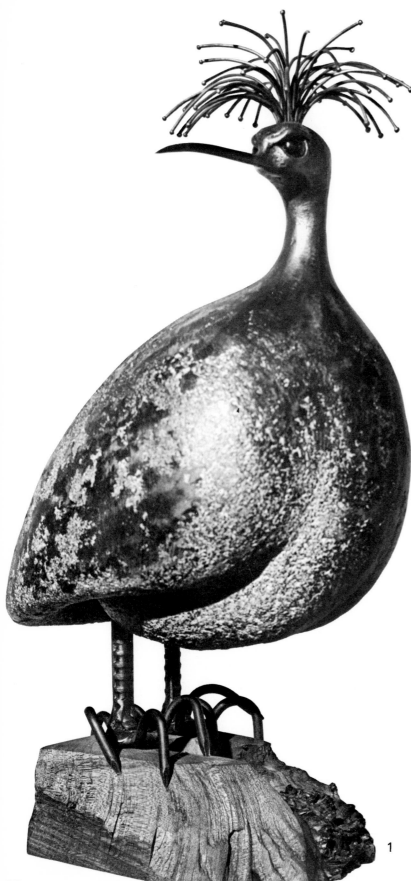

1. *"Very Pretty Bird" by Lou Rankin is of concrete body with ste[el] and nails for legs and plastic, glass and steel head. Plastic coat[ing] preserves metal parts.*

2. *Detail of sculpture made of wire, sheet metal, washers, and scu[lp] metal has been given spray coat of flat black, followed by a pati[na] of blue casein with some white added. Patina emphasizes textu[red] surfaces.*

3. *Experiment with various surface treatments. This one is calle[d] "Sculptage" and incorporates a special process designed by art[ist] William Bowie. Courtesy The Sculpture House, New York.*

4. *Seated figure of wire and sculpmetal has finish of flat black prim[er] paint and a patina of gray casein. Lutheran High School, Los Angele[s,] California.*

3

4

required in all the rubbing operations, and the young artist must be sensitive to the desired end result, so he may stop at the right time.

Sprayings can be made over another spray color, and if done from certain angles, can emphasize depth and textures.

To emphasize texture, it is possible to dry-brush casein paint over the sculpture, touching only the high relief features. Extreme care must be taken to have a very dry brush, as too much paint will spoil the intended result. Work can be made permanent for outdoor use by painting or spraying with an acrylic medium, either clear or in color. Some clear epoxy paints and clear plastics will also make the construction impermeable to water and rusting.

WIRE SCULPTURE/MOUNTING AND DISPLAYING

One of the most impressive sights in Florence, Italy, in a city abounding with impressive monuments, is to enter the Academia and see Michelangelo's "David" for the first time. David's feet are at your eye level and his potentially powerful form looms upward toward the domed ceiling. He is illuminated with an almost mysterious light source which emphasizes the whiteness of the marble and the subtle shadows of the muscle structure. The sculpture is wonderful, and the mounting of the figure and the lighting serve to increase the aura of wonder.

Normally simple sculptures can suddenly become impressive if mounted tastefully and fine sculptures are further enhanced with fine mounting techniques. Lighting, sensitive to the requirements of the sculpture, can emphasize texture, curves, subtleties, or any other quality desired. These are the final steps in completing any three-dimensional form. It is possible also that the sculpture is perfectly at home

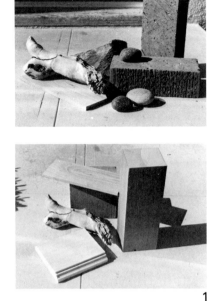

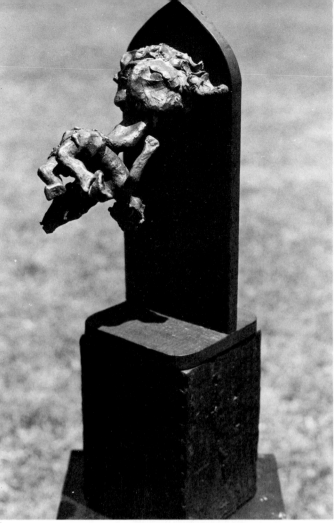

1

2

on a table without a base. This is a decision that the artist must make.

MATERIALS

Wood blocks are the most common mounting material, but are by no means the only one. Stones, carved material, pieces of driftwood, bricks, poles, and slabs are all usable. Glue, nails, brads, staples, and wire can all be used to hold the sculpture in place on the mounting material.

PROCEDURES

It is best to gather several mounting materials and try the sculpture on each one, selecting the one that enhances the piece of work, and presents it to its best advantage. Don't allow the mounting to over-

power the sculpture. Scrap blocks of wood are obtainable from cabinet shops or lumber yards. Stones, bricks and carved wood and stone scrap are available from a variety of sources.

Hold the sculpture in place on a number of bases and when satisfied, decide how best to keep it there. It might be glued in place with an epoxy glue. It might be nailed or wired in place on top of the block. A hole might be drilled into the block or brick and a protrusion of the sculpture forced into the hole and held in place with glue.

It is not necessary to always mount the sculpture on top of the base. It might be more effectively positioned on the side of the block, suspended from a part of the block, or placed into the block. The

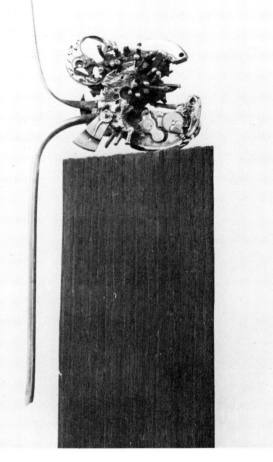

3

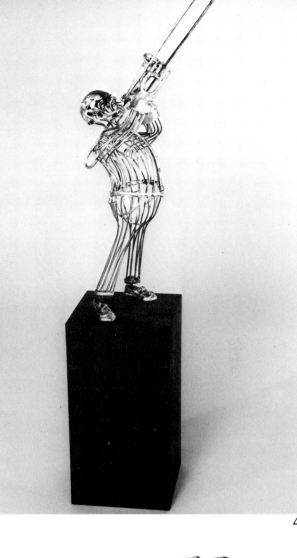

4

block should be finished by oiling, varnishing, lacquering, or painting, unless it is a type of wood or driftwood that might be better left uncoated. Perhaps it is to be wall-mounted and needs no block at all, or maybe the sculpture is free-standing and will look best on a shelf without a base. Whatever the case, try several, and choose carefully.

When finally finished and mounted, the work is ready for displaying to its best advantage. Sculpture is usually enhanced by lighting which comes from a limited number of sources, as from above or from above and one side. This type of light source emphasizes the quality of texture and also causes a greater visual perception of depth due to intense shadows. Over-all light tends to flatten the figure and de-emphasize texture.

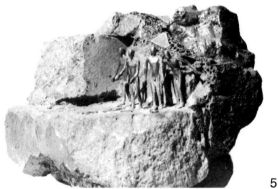

5

1. *Scraps of wood and bits of stone or bricks are raw materials for many attractive bases for wire sculptures.*

2. *Sculptured forms might be shown to better advantage mounted on the side of the block instead of on top. Bronze angel and cloud are by Arthur Geisert.*

3. *Protrusions of the sculpture might move down the side of the mounting block as this assemblage of watch parts and brass does. Sculpture is by Reinhold Marxhausen.*

4. *Tall block can enhance the height of a sculpture, as this trombone player of welded steel by Russ Shears.*

5. *"Figure Group", a bronze by Robert Snider, is mounted in the block of stone rather than on top of it.*

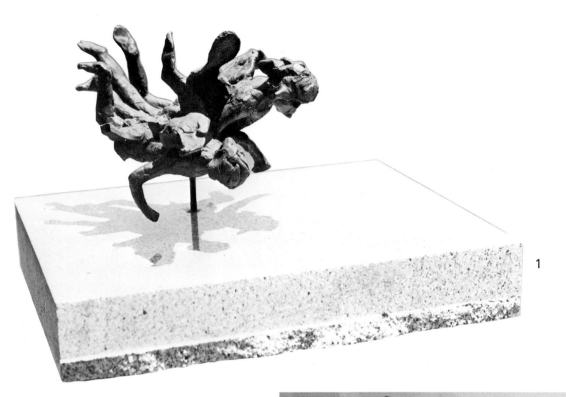

1

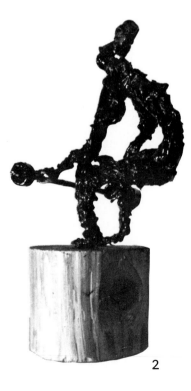

2

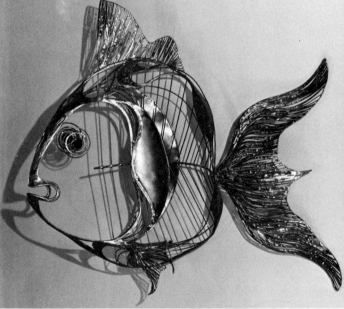

1. *Bases need not always be wood. This stone slab makes attractive base for small bronze angels by Arthur Geisert.*

2. *A round piece of tree branch makes a different yet handsome base for this wire and sculpmetal sculpture. Lutheran High School, Los Angeles.*

3. *Some sculptures don't need a block at all, but can be mounted directly on the wall. Provisions must then be made for hanging. Welded wire fish is by Russ Shears.*

4. *Traditional mounting of finished wood block and metal rod forms an appropriate base for the sweeping movements of this polished steel sculpture by William Bowie. "Convolution #102" is shown by courtesy of The Sculpture Studio, Inc., New York.*

5. *Long strip of walnut matches stride of this roadrunner sculpted by Russ Shears.*

Place objects near a window and rotate it to show the shadows. Place a single strong light on it and notice its contours and textures. The final location and positioning of the sculpture might be determined by the source of light which illuminates it.

OTHER IDEAS

While work is going on, discuss where the finished piece of work might effectually be placed: on top of a television set, on a mantel, bookshelf, coffee table, on a free-standing block, on the floor, in front of a window, backed by a plain painted wall, down low, at eye level, and so on. This matter of environment will determine its finish and color, and will give the young artist an idea of how the professional works on a commission for a certain place.

4

5

It is a good idea to have an area of the art room prepared for looking at the finished sculpture. It is surprising how the isolation of a student's work, placing it on a pedestal, lighting it and providing a proper background, can enhance the work and show its true value. Another thought would be to bring the photography class in to take pictures of the finished sculpture. Creative efforts as to angle, lighting, and composition, as well as environment and close-up approaches might prove stimulating problems. The end result will be that the student artist who created the original will get an appreciation of how others see his sculpture.

1

Chapter III

WOOD CONSTRUCTION

WOOD CONSTRUCTION/INTRODUCTION

Pile a bunch of wood shapes in front of an art student and the immediate impulse is to start building. The warmth and characteristic ''feel'' of wood are conducive to handling, forming, stacking, and general manipulation of the shapes.

In recent years, sculptors have used wood creatively, not only in carving and other subtractive methods of work. Nailing, laminating, pegging, screwing, bolting, and gluing are in the technique vocabulary of the constructionists. Assemblages using similar woods, dis-similar woods, pre-cut pieces, found pieces, or any combination of wood shapes have made their way from studios to galleries and museums. Finished products are sometimes highly polished, sometimes left untouched. Often they are lacquered or varnished, or sanded and oiled. An exciting aspect of the processes is this continual possibility of individual expression. One student or artist might completely enjoy the ''finished'' look of a smooth and lacquered surface and he can work in that direction. Another might belittle such detailed craftsmanship and rather work in rough hewn timbers to show strength and massiveness. Both extremes are possible in the realm of wood construction.

Size is likewise of little problem. Some wood constructions are minute in size, some gigantic, all are valid. Some are made with toothpicks, others with telephone poles, but all are wood constructions. Some are free-standing, some wall-mounted, some can climb from floor to wall or go around corners.

Wood constructions might be finished so the grain and color of the wood will be an important part of the structure, or they might be painted or lacquered to be brilliantly colored and finished. The element of change is present from the beginning of the construction. The young artist might simply begin by tentatively stacking pieces of wood together and by trial and error arrive at a solution. He may change his mind as to shape, finish, color, size, type of mounting or any other of a number of variables. The creative act is definitely an on-going activity, changing direction often, but keeping a definite purpose in mind—that of developing an exciting piece of sculpture.

Assemblages might be stable in construction and dynamic in shape, or they may actually contain movable or moving parts. Some wood constructions have been made to be manipulated by the viewer, who thereby lends his creative interpretation to the assemblage of parts.

Occasionally the wood pieces can be carved or shaped and then assembled, or perhaps a treasure of formed pieces can be found in an attic or garage

2

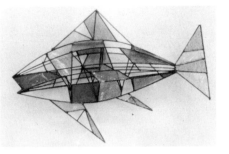

3

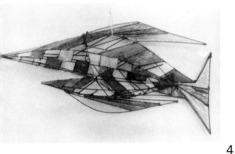

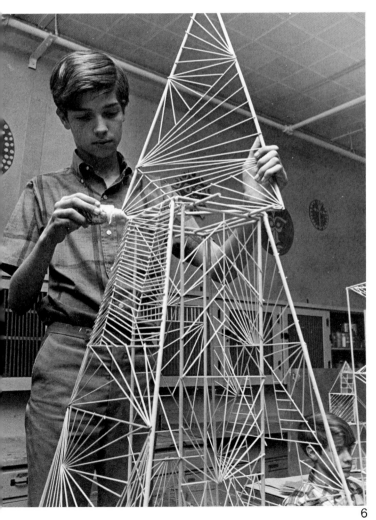

4

1. Teakwood bench designed and hand crafted by Milon and Mabel Hutchinson, Capistrano Beach, California.

2. Wood constructions begin with scrap piles like this.

3. Construction of applicator sticks and glue. Parkville Senior High School, Baltimore, Maryland.

4. Wooden stick sculpture with lacquered tissue paper to give stained glass effect. Jefferson High School, Los Angeles, California. (Los Angeles City Schools)

5. A variety of shapes, textures and colors of wood make an interesting composition. Lutheran High School, Los Angeles, California.

6. Giant wood dowel construction in the making, Le Conte Junior High School, Hollywood, California. (Los Angeles City Schools)

5

6

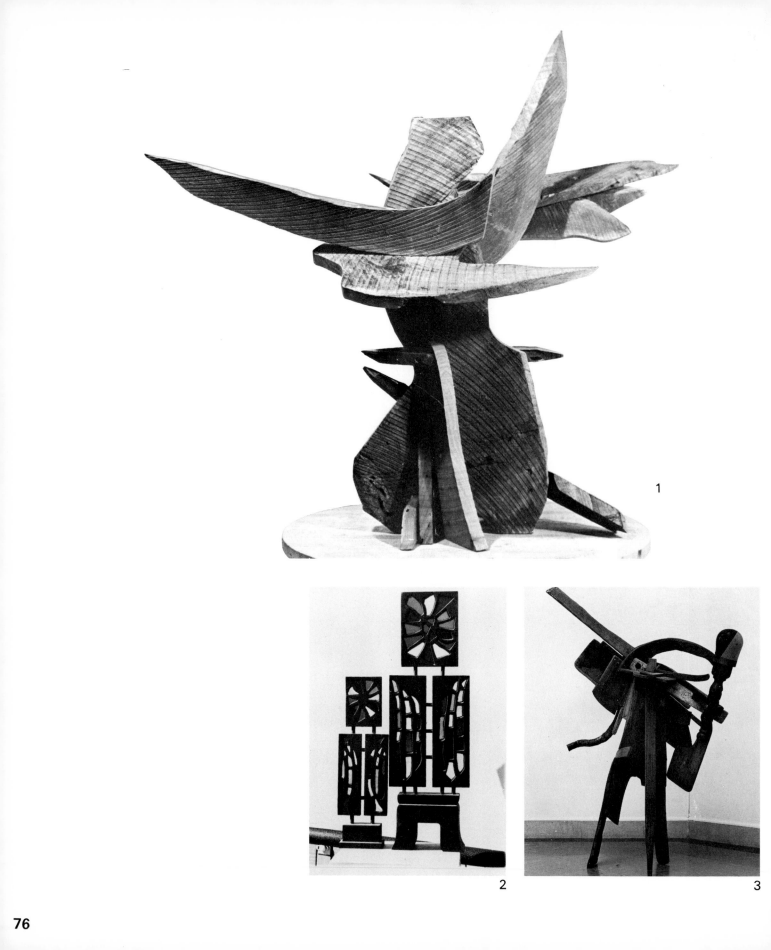

1

2

3

4

and developed into exciting arrangements and combinations.

There is hardly a limit to the kinds of wood material usable or to the number of ways of actual construction. Encourage experimentation and the results are bound to be stimulating and exciting.

MATERIALS

Local resources will determine the quantities and kinds of wood available for classroom use. A trip to local lumber yards and cabinet shops should provide a few boxes of scrap material for students to use. Students themselves can contribute scrap wood for a big resource box and perhaps school carpenters and shop classes and a search of the phone book can expose other sources.

Turned and shaped pieces are often available from auctions, old junk yards, and attic and garage sources, and these often add a unique touch to a construction. Soft woods are more easily worked and sawed, but the hard woods are beautifully grained and handsomely colored. Soft woods can be nailed and screwed together, while hard woods must be pegged or glued in place.

Nails, screws, bolts, and a variety of glues will serve to hold constructions together. Often combinations of these materials are best, using the appropriate holding device in the right place.

Tools will include drills, hammers, screwdrivers, coping saws, cross-cut saws, pliers, applicators for glue, and an active imagination.

WOOD CONSTRUCTION/RELIEF

Not all wood constructions are designed to stand freely and be viewed from all sides. Many artists

5

6

1. *"Marseillaise", walnut wood construction by Nat Werner. Courtesy The American Craftsmen's Council, New York.*

2. *Plywood and stained glass construction by Westwood Winfree. Courtesy American Craftsmen's Council, New York.*

3. *"Come One, Come Two", wood construction by Arlo Acton. Collection, San Francisco Museum of Art, San Francisco, California. Gift of the Women's Board.*

4. *Wood and cellophane construction, Bancroft Junior High School, Los Angeles, California. (Los Angeles City Schools)*

5. *"Acrotere", laminated wood construction by Gabriel Kohn. Collection, The Museum of Modern Art, New York.*

6. *Construction of applicator sticks and glue, mounted in a ball of clay. Parkville Senior High School, Baltimore, Maryland.*

work with wood in relief, with the finished product mounted on a wall to be viewed from a limited number of angles. Even in the rather restricted classification of wood relief, there are numerous areas of experimentation.

The wall sculpture might be of low relief or high relief. It can be painted or left untouched. It can be in a confined shape or left to wander in a free-form composition. Glued blocks might be allowed to overlap or only set side-by-side. Portions might be glued together in units and then combined, or parts could be added one by one. Work could be monumentally large or a small study of only several square inches. The woods used might be all pine, or might vary in color, texture, and hardness. And a multitude of combinations of these possibilities are available for the working.

MATERIALS

Woods of all types and shapes should be available in a large scrap box. If only one type of wood can be obtained, the problem should bear that limitation. It isn't a restriction, but only limits certain aspects of the problem. Most of such relief problems become exercises in putting together a creative jig saw puzzle, with the artist providing the pieces and the design as he goes along.

Half-inch plywood or pine one-by-twelves make good backings for nailing pieces in place. If wood parts are to be glued, Masonite, particle board, or any flat wood surface is excellent. Nails could be counter-sunk and the holes filled with wood dough to disguise them, or they might remain visible and become part of the sculpture.

If the sculpture is to be painted, vinyl paints of any degree of flatness or glossiness are excellent. The work could be lacquered, varnished, or sprayed, depending on the artist's desire. It might be gessoed or given a coat of casein or oil colors. Perhaps it will all be painted one color, or given a multihued surface of op-art characteristics. Collaged surfaces might be worked onto several or all of the blocks. Finishes are many and varied and experimentation is again a key word, since all the possibilities haven't been explored as yet.

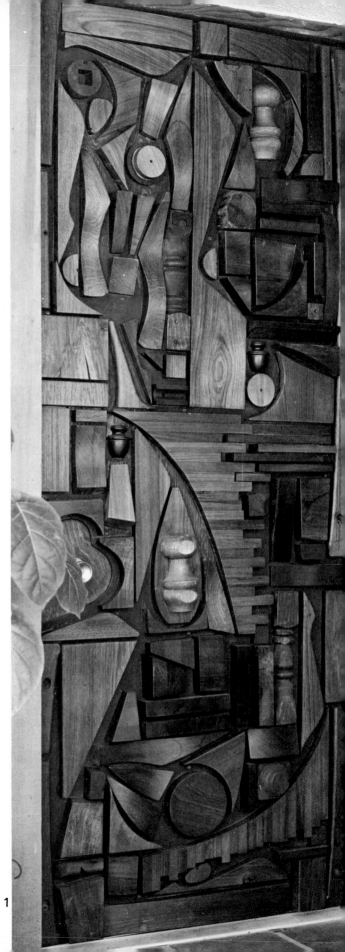

1

2

3

4

1. *Teakwood door on home of Virgil Partch, by Mabel Hutchinson.*

2. *"White Anxiety", painted wood relief construction by Gertrude Greene. Collection, The Museum of Modern Art, New York. Gift of Balcomb Greene.*

3. *"Birds in an Aquarium", painted wood relief by Hans Arp. Collection, The Museum of Modern Art, New York.*

4. *Construction of scrap walnut in fairly high relief. Lutheran High School, Los Angeles, California.*

5. *Detail of relief wood construction in variety of shapes and woods. Lutheran High School, Los Angeles, California.*

5

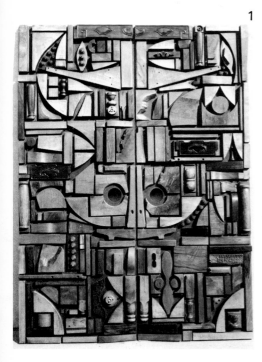

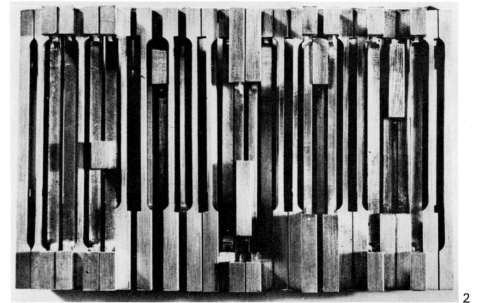

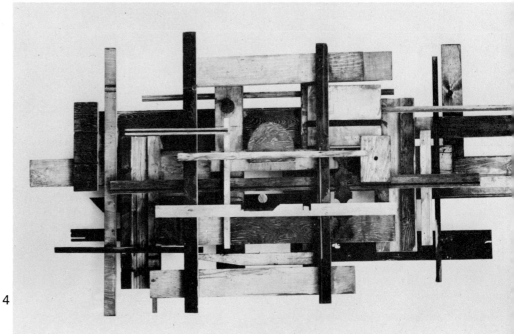

1. *Double doors relief construction of mixed woods by Mabel Hutchinson.*

2. *"Memorial Wall" detail of welded aluminum construction by Herbert Feuerlicht. Collection, Museum of Contemporary Art, Skopje, Jugoslavia. Courtesy, American Craftsmen's Council.*

3. *"Sky Cathedral", painted wood construction by Louise Nevelson. Collection, The Museum of Modern Art, New York, gift of Mr. and Mrs. Ben Mildwoff.*

4. *Wood wall sculpture of various tones of red stained wood, by William Bowie. Courtesy The Sculpture Studio, Inc., New York.*

5. *Walnut relief construction, Lutheran High School, Los Angeles.*

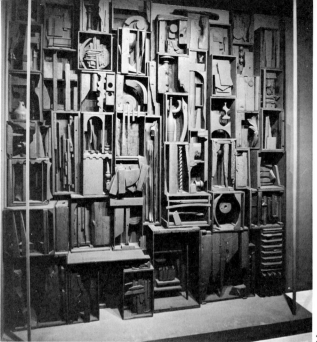

3

PROCEDURE

Select the kind of woods to work with and handle them. Move the pieces around and find out what can be done with them. If a certain design pattern is desired, a drawing in light pencil can be made right on the backing sheet of Masonite, plywood or flat wood surface to serve as a guide.

Wood pieces can be adhered to the backing panel by nailing or gluing. Preconceived ideas should not be absolute, but change in plans should be encouraged as the forms develop. If nails are used, they might be made part of the sculpture, or they can be covered. Care should be taken with the glue, if the assemblage is to remain unpainted, because the shiny glue surface will stand out against the flat wood textures. If the final product will be painted or varnished, the glue surfaces will not bother the result.

OTHER IDEAS

It might prove interesting to develop a problem around similarly shaped pieces of wood to see what variety of arrangements can be produced.

It is also exciting to get many kinds, textures, and colors of wood with varieties in shape and size, and form the constructions from them.

Don't overlook easy-to-get materials in your wood constructions, such as dowels of various sizes, applicator sticks, popsicle sticks, wooden slats, and branches of trees and bushes cut crosswise. All can add interesting new shapes to what might be rectangular design content.

Explore local wood industries for possible uniquely-shaped scrap material. If you are located in an area where old houses are in process of demolition, watch for interestingly-turned shapes of balustrades, porch supports, and railings, and also for a variety of carved and turned decorative panels and supports. These can be used as is in free-standing forms, or can be sliced, crosscut, or sawed diagonally with shop equipment to provide scrap boxes with intriguing shapes.

TYPICAL PROBLEM/WOOD RELIEF

Take several pieces of wood, varying in thickness and shape, and cross cut them into a large number of flat pieces, varying in thickness from ½ inch to 2 inches. Glue these pieces to a sheet of plywood or Masonite to form interesting patterns. (Many variations as to treatment of wood, finishing, building up relief areas, and the like.)

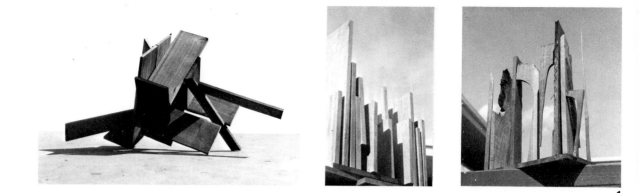

1

WOOD CONSTRUCTION/FREE-STANDING

Infinite variety can be obtained in working with free-standing wood constructions. They can be highly disciplined and architectural in their feeling or they can be organically free-formed in arrangement. They can be small in size and be comprised of detailed sections, or they can be huge in scale and of simple slab-like shapes. They can be left to show the beautiful wood grain or can be painted or collaged in gaudy, circus-like colors. Variety and change are constant companions of such builders.

MATERIALS

Wood pieces of all types are the raw material from which free-standing sculpture is constructed. Scrap, purchased pieces, found driftwood, sawed parts, turned chair and table legs, dowels, wooden boxes are only part of the resource material. These can be glued, epoxied, nailed, strapped, screwed, bolted, or pegged together into an infinite variety of shape and form.

If slabs are not thick enough, several can be laminated together with white vinyl glue to form a thick chunk. If pieces are too thick they can be ripped or split to desired thinness. But the well-heeled scrap box should provide most of the materials needed. Finished constructions can be left natural or can be varnished, oiled, lacquered, sprayed, brushed, painted flat, collaged, or given a psychedelic treatment. Variety in finishes are almost as numerous as the quantity of forms that can be constructed.

PROCEDURE

Totem effects can be constructed by erecting, on a base, a core shape of a two-by-four or other beam or timber, and nailing or gluing blocks and pieces of wood to it. These pieces might form a disciplined architectural pattern or they may be any of a variety of free-formed totems. Soft woods can be nailed, hard woods must be pegged or glued in place to lessen the chances of the wood splitting.

Free-formed sculptures can be built up by nailing, gluing, or banding varieties of shapes together to produce a cohesive unit. Perhaps some altering needs to be done to achieve certain effects, or the problem might simply involve a required number of pieces with no alteration. Constructions can be severely plain or elaborately complex.

Exciting lidded boxes can be developed by combining turned wood parts, wooden drawer knobs, dowels, blocks, found wooden pieces, or spools. The resulting totem-like lids can be painted and/or collaged to produce stimulating visual products. The boxes can be built of squares of Masonite, chipboard, or plywood and glued together. These also can get the full fun-colored treatment. Sources for decorative ideas are easily gathered from magazines and current advertising materials.

OTHER IDEAS

Art magazines and gallery and museum visits will provide numerous other ideas that can be adapted

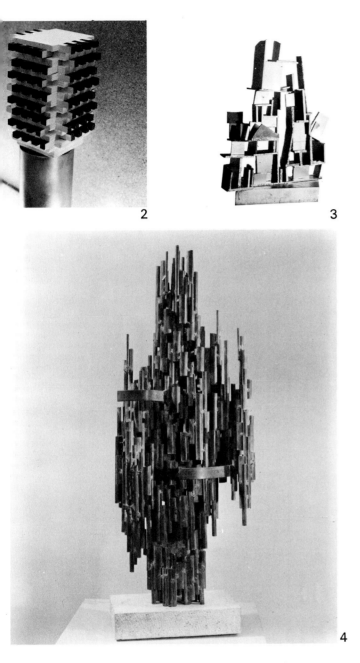

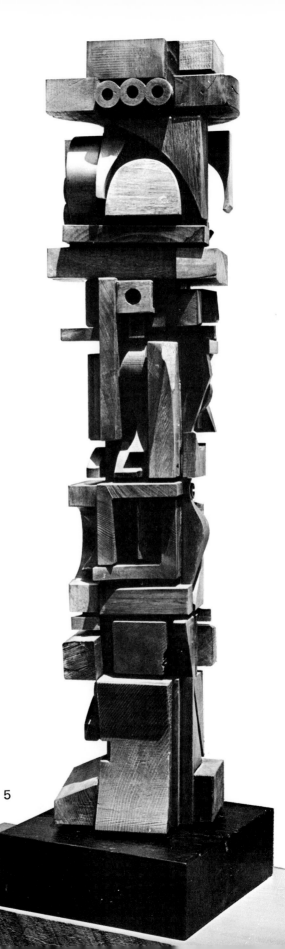

1. *Scrap walnut constructions, Lutheran High School, Los Angeles, California.*

2. *Painted softwood construction by Stephen G. Brown.*

3. *Scraps of hardboard, sprayed with metallic paint, Baltimore City Schools, Maryland.*

4. *"Young Girl", by Noemi Gerstein. Collection, The Museum of Modern Art, New York. Inter-American Fund.*

5. *Hardwood totem construction of Mabel Hutchinson.*

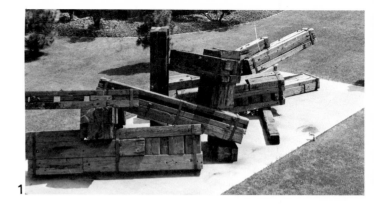

1. *"Dedication to Ken Glenn", an anonymous student project of bound timbers, constructed on the campus of California State College in Long Beach, California.*

2. *"Duet", thick steel construction by Robert Murray. Courtesy, California State College at Long Beach.*

3. *"Construction of Volume Relations", mahogany construction by Georges Vantongerloo. Collection, The Museum of Modern Art, New York, gift of Miss Silvia Pizitz.*

4. *"1950", wood construction by Robert Maki, courtesy American Craftsmen's Council, New York.*

5. *"Fenris", construction of hardwoods by Erik Gronborg.*

6. *Colorfully decorated boxes and elaborate lids, Le Conte Junior High School, Hollywood, California. (Los Angeles City Schools)*

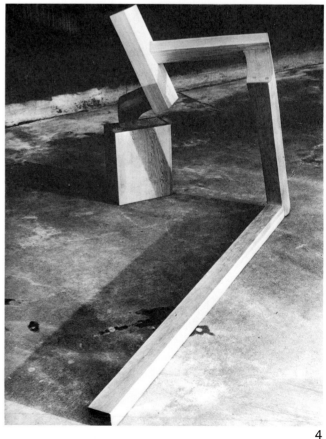

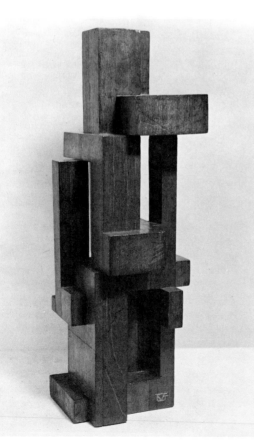

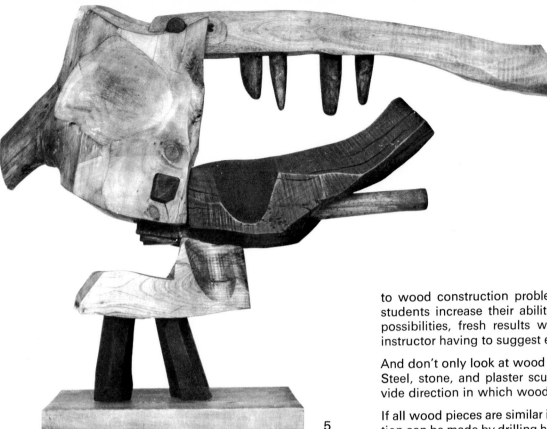

5

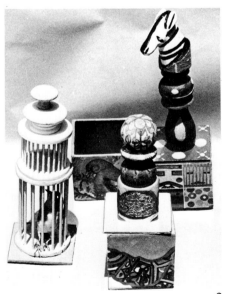

6

to wood construction problems in an art room. As students increase their ability to see such adaptive possibilities, fresh results will emerge without the instructor having to suggest each and every move.

And don't only look at wood constructions for ideas. Steel, stone, and plaster sculptures might also provide direction in which wood might be worked.

If all wood pieces are similar in shape and size, variation can be made by drilling holes or making saw cuts in certain pieces to relieve the sameness.

Funny little never-seen-before animals can be constructed of wood scraps and can be painted vivid colors. These make wonderful gifts, especially to children's hospitals.

TYPICAL PROBLEM/WOOD CONSTRUCTION

Take a 2 by 4, about 2 feet in length, and nail *and* glue it to a wooden base. Using only 15 pieces of scrap wood, and allowing for no alteration, nail or glue them to the core 2 by 4. This totem should be painted vividly using a minimum of five colors. Colors should be applied over a sealing coat of white primer. If oil, casein, or acrylic paints are used, no sealer is needed over them. If tempera is used for color, the finished totem should receive a coat of protective shellac.

WOOD CONSTRUCTION/TOOTHPICKS

Geometric shapes, cantilevered reaches, bunched and strawlike structures, or disciplined forms are all possible constructive techniques when working with toothpicks. And they will probably turn up every time this problem is introduced. One of the most used forms of wood assemblage in classrooms, the fact remains that toothpick construction is a valuable constructional experience.

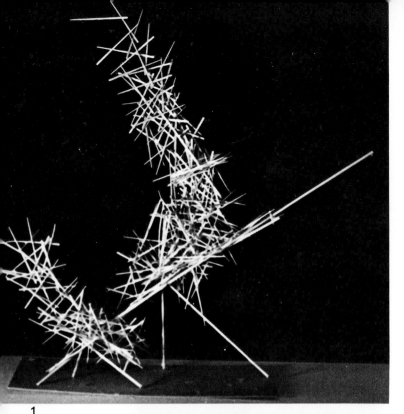

1

2

Practical problems of balance, proportion, and methods of support are all encountered. Esthetic problems of balance, interesting shapes and over-all feeling are to be solved. As the structure develops, care must be taken to view it from all sides, making certain that indentations and protrusions are varied and interesting.

Often a belittled art experience, toothpick structures provide opportunity to meet problems never encountered in other materials and techniques. Permanence is a doubtful feature, but the working experience is sound enough to overcome this factor.

MATERIALS
Toothpicks of various types are on the market, but the least expensive are best for constructions of most types. The flat slivers of wood are more versatile and provide a better gluing surface than the round or polished ones.

Airplane model cement is the quickest drying adhesive material to use. It becomes brittle with age, but allows students to work rapidly and accomplish much in one period of work. Interesting additions to toothpick structures can be made by adding lengths of curved reed or by incorporating applicator sticks or thin doweling into the forms.

3

1. *Toothpick construction, Lutheran High School, Los Angeles.*

2. *Interesting toothpick variation, Lutheran High School, Los Angeles, California.*

3. *Toothpicks sprayed with tempera, Baltimore City Schools, Maryland.*

4. *Construction using repeated geometric units, Lutheran High School, Los Angeles, California.*

5. *Reed and toothpick construction, Baltimore City Schools, Maryland.*

6. *Cocktail picks and glue construction, Baltimore City Schools, Maryland.*

7. *Steel structured Eiffel Tower, Paris, France; Courtesy Societe de la Tour Eiffel, Paris.*

7

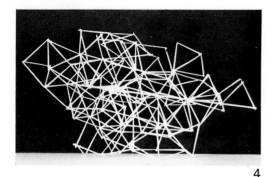

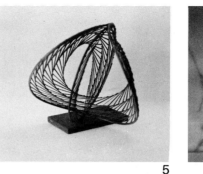

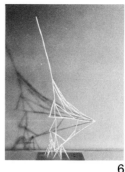

4 5 6

PROCEDURES

Begin with a piece of chipboard as a base and by placing several drops of cement on it start a toothpick foundation for the structure. Additions are made to this foundation in any direction desired. Structures can be built up in geometric modules of repeated units, or can be expanded in a more organic way.

If the cement doesn't set fast enough, blowing on it will hurry the drying process. Encourage students to turn the sculpture often while they are working so a true three-dimensional quality develops. It must be made to look interesting from all sides, even though one view might prove most satisfactory.

OTHER IDEAS

Bits of colored tissue or pieces of plastic can be adhered to the structure to add color emphasis. The structure can be spray painted if desired or a completely different effect achieved by pouring plaster of Paris over it or dipping it in a plaster bath.

Toothpicks can be combined with other materials: wood chunks or strips, reed, sticks, and various strips of balsa wood.

When work is finished and taken home, left-over structures can be combined, by gluing into a huge cooperative assemblage, and suspended from the ceiling.

It is best to keep structures non-objective, so students don't get frustrated trying to make "something" out of toothpicks. Strive rather for interesting over-all shapes and textural treatment.

Shine a bright light through the structure and note the resulting shadow on a wall or screen. Turn the sculpture and watch the line-shadow-form change on the wall.

Finished forms might be taken off the base and suspended from the ceiling or allowed to stand alone on a table. Or the base might remain attached and tacked to a wall.

TYPICAL PROBLEM

Construct a toothpick structure using model airplane cement as the adhesive. One other material (wood, paper, cloth, cardboard) may be introduced. Completion in five class periods. Restriction: artist must be able to get it through the classroom door. Structure to be left unpainted.

Chapter IV
CARDBOARD AND PAPER

INTRODUCTION

Some of the most common and neglected materials can often stimulate interest in three-dimensional activities. Creative construction materials need not always come from an art product supplier, but might be materials already on our shelves or easily obtained from scrap and throw-away piles at stores and even at school. Cardboards and papers of various types are easily formed and worked and can provide delightful and stimulating three-dimensional exercises.

Cardboard and paper come in an awesome array of thicknesses, finishes and colors. They can be glued, stapled, cemented, paper-clipped, or pinned into place. They can be notched and slipped into place to hold themselves. The resulting shapes can be painted, sprayed, or left alone. They can be mounted on wood or on a box made of cardboard, left free-standing or stuck on a wall. Variety is evident, and how far students carry their experimentation is only limited by the extent of their inventive imaginations.

MATERIALS

Types of cardboard that can be used include chipboards, railroad boards, poster boards, corrugated cardboards, tag board, and a variety of boards with local trade names. A visit to an art supplier, lumber yard, or stationery store will undoubtedly turn up several types.

Papers, both heavy and light, can be used alone or in combinations with the heavier boards. Entire volumes have been written on paper sculpture as such, and it will not be discussed here. Not that it wouldn't fit—it would—but your library probably has several books on the subject already.

IDEAS

When looking for contemporary sculpture to show to students, the instructor will find it difficult to locate things done in cardboard. But sheet steel is another story. Plenty of work is being done today in stainless and sheet steel of various types—some in combination with rods, some in sheet steel alone. Cardboard sculptures, when painted, may easily give the feeling and appearance of large welded sheet steel structures, only in smaller scale—almost like a model for the metal sculpture. Current art magazines and sculpture catalogs should have examples of such work.

1

2

1. *Model for concrete structure by Andre Bloc, courtesy California State College at Long Beach.*

2. *Decorative sculpture of sheet steel by Glen Alps. Courtesy American Craftsmen's Council, New York.*

3. *Detail of cardboard and wood construction, Jefferson High School, Los Angeles. (Los Angeles City Schools)*

3

1

2

CARDBOARD/RELIEF

Subtle elevations and cast shadows are the most interesting features of wall reliefs designed from cardboard. Painted monochromatically, they call attention to their designs by the shapes of the shadow areas. Easily constructed with bits of cardboard and paper, they can prove to be handsome wall decorations.

MATERIALS AND PROCEDURES

Start with a sheet of chipboard or Masonite and cut lots of shapes out of lighter chipboard, gluing them to the backing to form the design. Scraps of mat board, chipboard, heavy paper or other cardboard can be used, and shapes can be geometrically or haphazardly cut, depending on the desired outcome.

The cutout pieces can be placed on the backing sheet and moved around until satisfactory. Designs can be piled up to several thicknesses of cardboard or left rather flat, and they can be abstract in their character or might represent some recognizable subject matter.

Careful placing of the cutout forms is critical to a good design, since careless application will only result in a pile of painted cardboard pieces. Vary the sizes and shapes, perhaps, or vary the thickness to add interest.

6

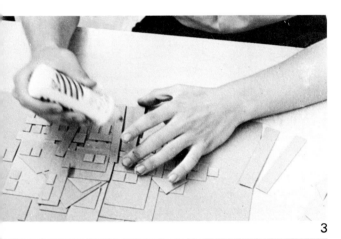

3

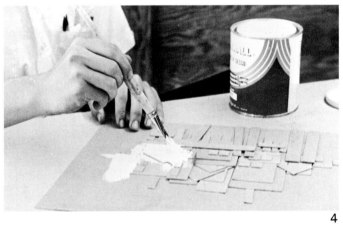

4

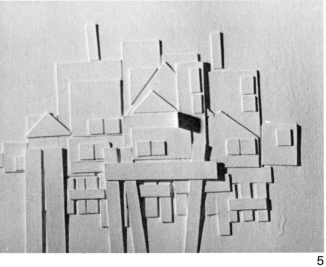

5

1. *Assemble scraps of cardboard.*
2. *Use razor blade to cut into desired shapes.*
3. *Glue cutout shapes to backing board.*
4. *Apply several coats of gesso.*
5. *Display using oblique light to emphasize shadows.*
6. *"Horizontal White Relief", cardboard relief painted with white polymer, by Eduardo Ramirez Villamizar. Collection, The Museum of Modern Art, New York, gift of Miss Silvia Pizitz.*

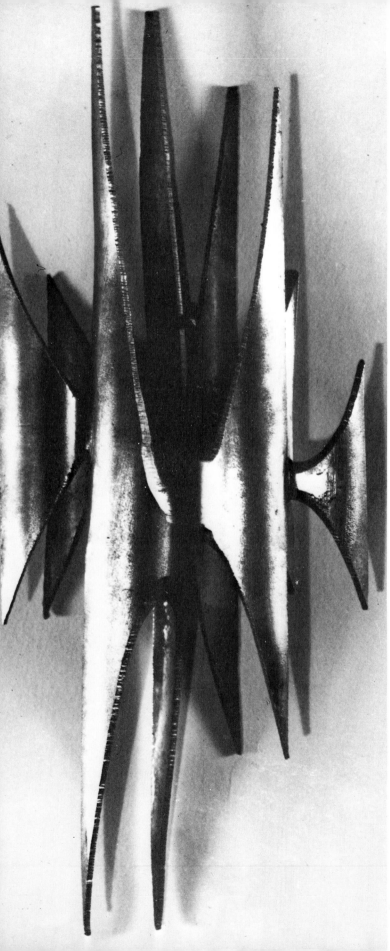

When satisfied with the formations, the pieces should be glued to the backing and to each other if necessary. All pieces might be flat or some might be turned on edge and glued. White vinyl glue or rubber cement are good for adhering the relief together, with the former being far stronger, especially when painted.

When the design is satisfactory, the entire surface can be painted with gesso or with a flat acrylic paint. The entire design can be painted one color, or it can be given a multi-hued application of paint. The subtleties of the relief are often lost when more than one color is used.

TYPICAL PROBLEM

Take a sheet of ⅛ inch chipboard about 15 x 20 in size, and glue to its surface a variety of cardboard shapes to produce a relief structure. Subject matter may be representational or abstract, but the final surface should be painted with white gesso or white casein paint.

CARDBOARD AND PAPER/FREE-STANDING

Discarded mailing tubes, paper towel rollers, corrugated cardboard, and scraps of old posters are the raw materials for some pretty exciting experimentation. The chance to work with a flexible material is welcomed by art students, especially when they can experience the ease with which the material can be worked.

There is no need to belittle such cardboard structures as being beneath the serious art student in quality of material. Properly painted and mounted, the structures can be very attractive and at times quite sophisticated. Since few professional artists work in cardboard for exhibit purposes, viewing sculpture done in sheet steel might tend to stimulate student thinking and generate ideas.

Another beneficial aspect of working with cardboard as a material is the quickness with which the structure can be completed. Much experimentation, several problem solving experiences, and the final

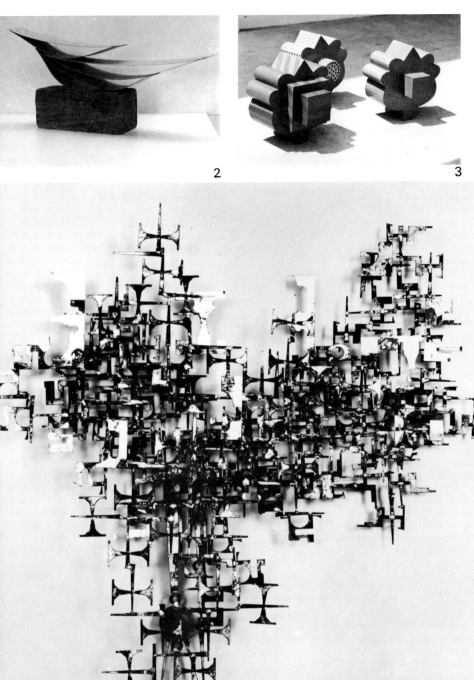

1. "Sentinels" by Herbert Feuerlicht is a model for a large architectural sculpture, but provides ideas for cardboard construction. Courtesy American Craftsmen's Council, New York.

2. Strips of cardboard, stapled at the ends to produce a tension, are glued together to form graceful shapes.

3. Sculptured cardboard boxes by Edie Danieli, courtesy Orlando Gallery, Encino, California.

4. "Patterns", silver and gold leaf steel wall sculpture by William Bowie. Courtesy The Sculpture Studio, Inc., New York.

2

3

4

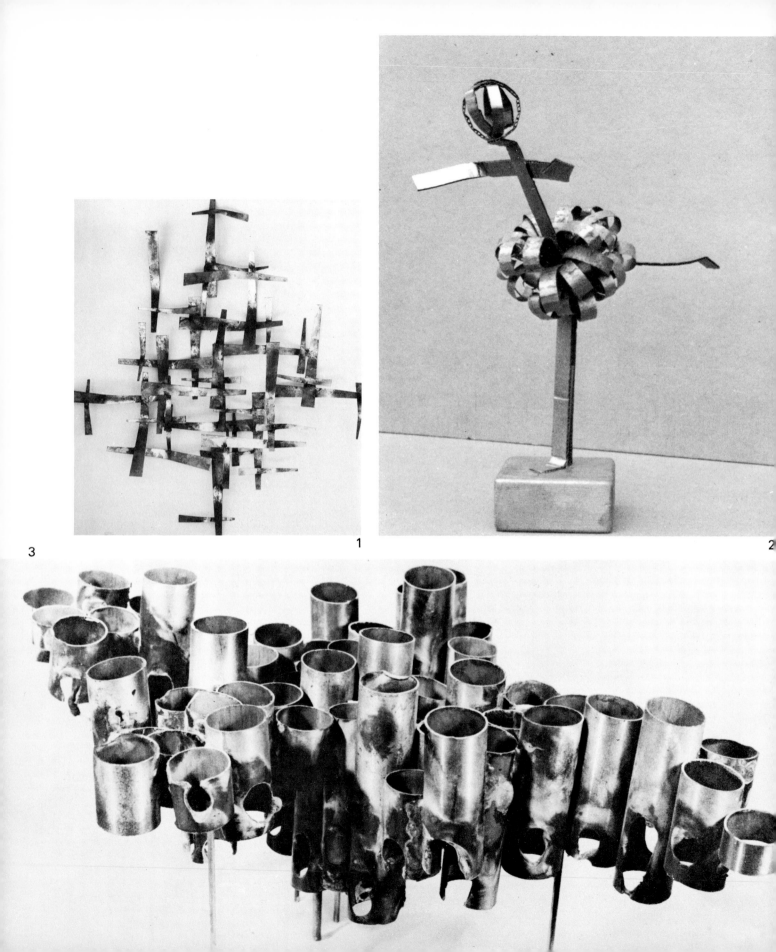

3

1

2

result can all be accomplished in the span of one class period. Refining, finishing, and mounting might take some more time, but the entire project is quite rapid compared to many other forms of construction.

MATERIALS

All types of cardboard are usable including flat sheets, strips, formed tubes, and boxes of all types. These can be glued, stapled, pinned, or placed together with interlocking notches, and joints can be left exposed or covered with modeling paste, gesso or sculpmetal.

PROCEDURE

Mailing tubes can be cut into a variety of lengths from 1 inch long to 1 foot, and these pieces placed together to form a clustered structure. The tube parts may be altered by cutting holes in some, texturing others by piercing, or notching some of the ends. They can be cemented together by placing rubber cement on both contact areas, allowing it to dry, and placing the pieces together for a firm bond. White vinyl glue might also be used. Into some joints thick adhesives might be introduced—gesso, modeling paste, or sculpmetal. This interestingly arranged composition might be suspended, mounted on a thin rod or two, placed into a block of wood, or made to stand free of any support. It can be painted bright colors, sprayed with metallic paint, given a thinned coat of sculpmetal, or given a patina.

Attractive wall-mounted or suspended sculptures can be made by gluing together a large number of cutout pieces of cardboard. They may be identical in shape and/or color, they might vary slightly, but with similar forms, or they could be quite varied. One surface might be collaged, the whole structure painted or sprayed, or if colored cardboard is used—left alone.

Cardboard can be formed into small boxes, glued together, and given attractive and interesting surfaces by painting or collaging. The boxes can be stacked and glued together, or supported on thin legs of wood, or suspended from a ceiling. Such little boxes might be square, rectangular, or be quite inventive in shape.

Corrugated or other types of cardboard might be formed into abstracted shapes or into human figures. Difficulty might be found in producing rounded shapes from flat cardboard, but inventive solutions are usually very interesting.

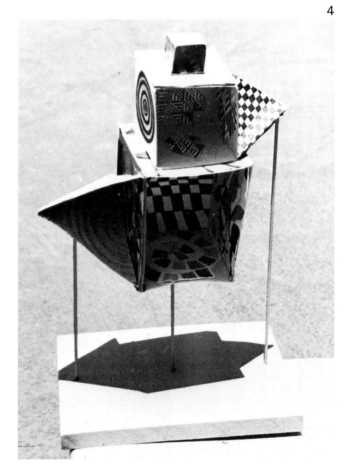

4

1. "Alpha", steel structure by William Bowie, courtesy American Craftsmen's Council, New York.

2. Dancing figure of cardboard and paper, Sun Valley Junior High School, Sun Valley, California. (Los Angeles City Schools)

3. Metal tube sculpture by Robert Snider, courtesy American Craftsmen's Council, New York.

4. Sculptured and decorated cardboard construction, Le Conte Junior High School, Hollywood, California. (Los Angeles City Schools)

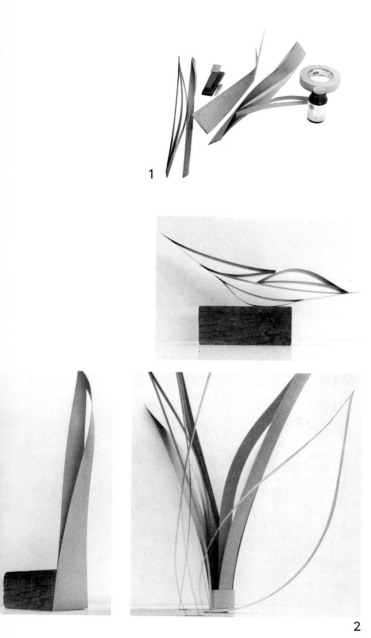

1

2

Tension can be obtained by taking two strips of cardboard, one a bit shorter than the other, and stapling the ends of the two together. This will produce a long and thin leaf-like shape. Experiment by twisting one of the pieces, using three pieces instead of two, using shapes instead of strips, or placing several of these tension units together at the ends and anchor them on a block of wood. Or glue or staple them together in the strip someplace, preferably not in the center, counter-balance, and mount them horizontally. Experiment. The curves described by some of these tension units are among the most beautiful three-dimensional shapes in existence. Have students hold such a unit in their hands, hold it at various angles from themselves and sight along the edges to see the gracefulness of the lines. Enjoy the simple arc or compound curve that the shapes describe. Experiment and enjoy the results.

OTHER IDEAS

Stubborn cardboard? Won't stay curved? Leave overnight or over a weekend, rolled up, and held in place by string or masking tape. BEFORE cutting out shapes or strips to use, glue a brightly colored poster or print to the cardboard on one side or both sides. Make razor cut edges as clean as possible, and no other finishing will be necessary. The brilliant colors will be scattered all over the structure.

Do you have a source for lots of cardboard boxes? You might want to paste words, letters, student work, or prints from magazines on some sides. Paint other sides bright colors with tempera or acrylic colors, and build a display or exhibit wall with them. Work around a theme, or merely present a cross-section of art to your student body. It can be very exciting, as you can see from the experimental walls designed by Los Angeles' Immaculate Heart College students, under the direction of Sister Mary Corita.

PAPER STRUCTURES/DRINKING STRAWS

Occasionally a building material is easily overlooked because of its close proximity, and its intended use in areas other than construction. One of these delightful materials is the lowly paper drinking straw. When glued together in a variety of ways, exciting structures grow quickly and easily under the students' hands. Large structures are of little weight, yet because of the hollow character of each straw, can be very strong. And because this building material is of paper, many glues will provide the binding agent for holding the structure together.

3

4

1. *Tools and materials needed for tension structures of cardboard might include cardboard strips, a stapler, rubber cement and masking tape.*

2. *Strips of lightweight cardboard stapled to attain tension. Lutheran High School, Los Angeles, California.*

3. *Display of covered cardboard boxes by Immaculate Heart College students at Century City, Los Angeles, California. Courtesy Century City, Sister Mary Corita, and photographer Milton Zolotow.*

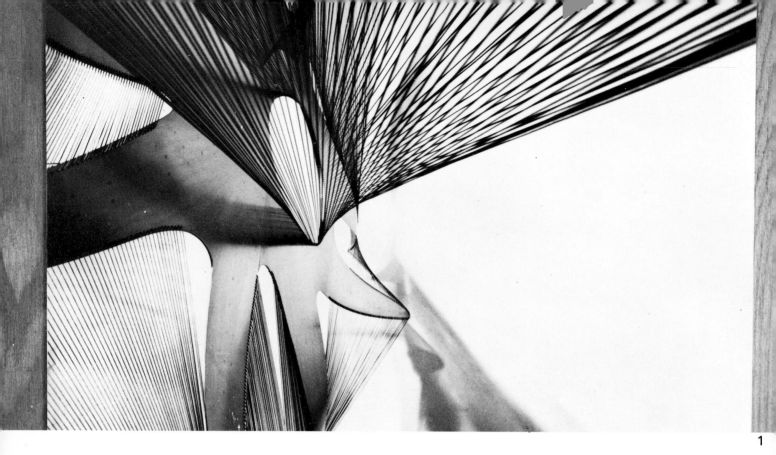

MATERIALS AND PROCEDURES

The more reasonable paper straws are fine to work with, but ones made of plastic and/or colored material shouldn't be overlooked for experimental purposes.

Glues should be chosen on basis of need. The most rapid drying adhesive would be the model airplane cement used in toothpick constructions. White vinyl glue is stronger, but requires more time and patience in drying. Search out adhesives that might have local commercial applications and experiment with them. Fine structures have been built using rubber cement, which was applied to both facing surfaces and allowed to dry, then placed firmly together for a firm bond. Experiment.

Straws can be used as they come from the box, can be cut with scissors to desired lengths, or can be bent at angles and incorporated into the structures. These attractive elbow-like bends can be a distinctive feature of an otherwise simple structure.

Finished structures can be painted, sprayed, or left unfinished. They can be mounted on wood, left unmounted, or hung from a ceiling or a wall bracket.

Look at sculptures made of steel rods for ideas. Large sources of wood dowels, perhaps available because of local industry, could be put to use in similar construction.

CARDBOARD AND PAPER/IMAGINATIVE PLAYGROUND EQUIPMENT

In the burgeoning field of product design, one of the most stimulating areas is in the design and construction of playground equipment. And junior and senior high school students are easily motivated into producing some truly exciting ideas.

Perhaps the most creative ideas come to form when safety restrictions are lifted. Let the safety engineers worry about that, or allow them to veto the idea as unsafe, but let the youthful designers have a design hand free of restriction.

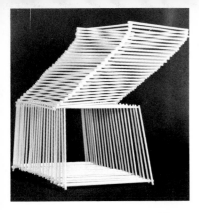

1. *"Energy", sculpture of aluminum and brass cable by Barbara Blair, courtesy American Craftsmen's Council, New York.*

2. *Structures of drinking straws and glue, Baltimore City Schools, Maryland.*

3. *"Space Sculpture", stainless steel sculpture by Norbert Kricke, courtesy The Los Angeles County Museum of Art, Los Angeles, California, gift of Mr. and Mrs. David Bright.*

4. *"Phoenix Desert", silver, bronze and steel sculpture by Herbert Feuerlicht, courtesy American Craftsmen's Council, New York. Commissioned by Copeland Novak and Israel, for Diamond Department Store, Phoenix, Arizona.*

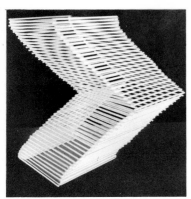

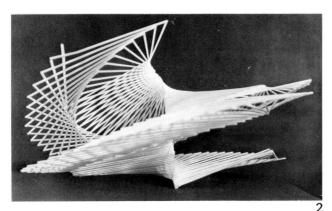

2

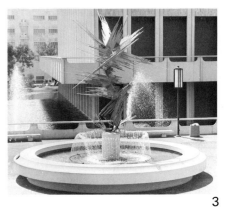

3

4

1

Discuss small children's play activities of climbing, running, crawling, sliding, swinging, going over, under, and around things in a variety of ways. And then design a playground item interesting enough to invite the children to come to it, and useful enough to satisfy one or more of these active urges.

MATERIALS

The three-dimensional models of such playground equipment are easily built of cardboard, balsa wood, applicator sticks, reed, paper, tissue paper, string, and/or scrap cardboard or wood materials. These are glued together and painted brightly to add color to the shapes that are already stimulating and inviting to youngsters.

PROCEDURE

Decide which of the activities the product will attempt to satisfy, and make some rough sketches of possible ideas. Once a format design is adopted, begin construction, using appropriate materials: cardboard can simulate sheet metal, balsa wood or thin dowels can be steel rods, tissue paper can be canvas, string or thread can be rope or cables, and so on.

Think about scale when working out the design. Have students make a small cutout figure to simulate a child and place him around on the structure as work progresses to remind the artist of size relationships. Use several figures like this to place on the finished product to show size and type of activity desired.

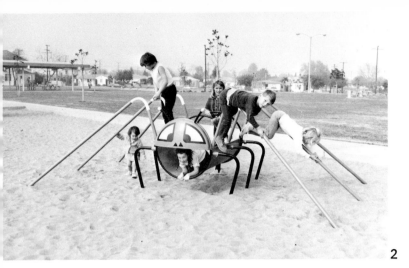

2

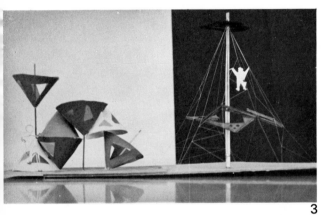

3

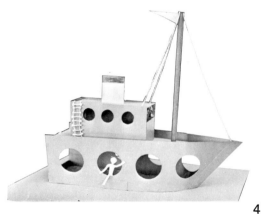

4

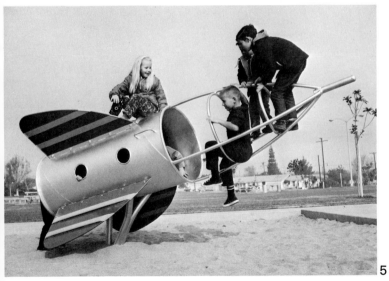

5

1. *Playground equipment models of cardboard, emphasizing climbing activities. All playground models are from Lutheran High School, Los Angeles.*

2. *Giant bug can accommodate several youngsters, courtesy Jamison, Inc.*

3. *Climbing and sliding are stressed in these two playground constructions.*

4. *A sandbox fills the hold of this boat, designed for small children.*

5. *Small rocket provides interesting climbing activities. All actual equipment shown here was designed by Ron Zick of Jamison, Inc.*

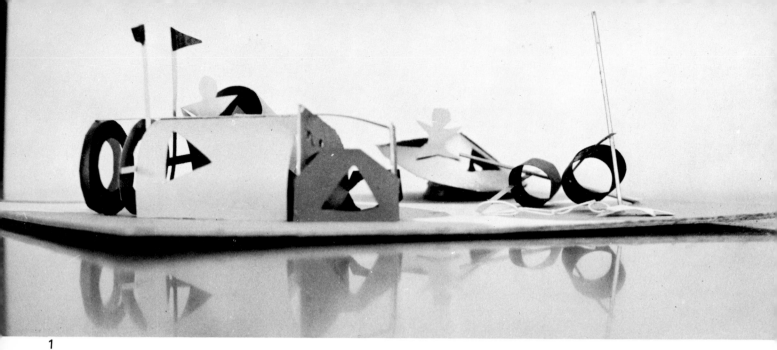

1

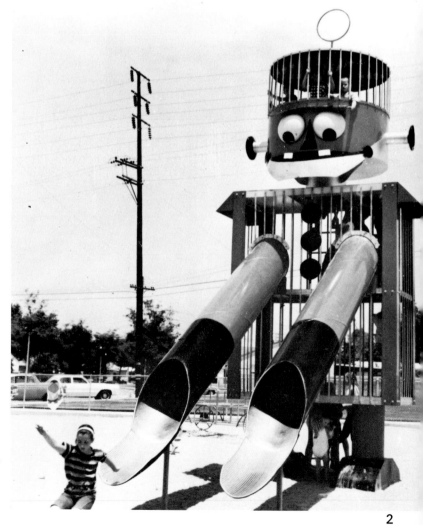

1. *Small children's activities are emphasized in this cardboard model.*
2. *Unique slides can exit children from robot cage, courtesy Jamison, Inc.*
3. *This tree can be climbed from the outside or the inside.*
4. *Climbing to the top of this slide could pose some problems for children.*
5. *Flying saucer provides several climbing surfaces for active youngsters, courtesy Jamison, Inc.*

2

3

4

If colored cardboards and papers are used, not much painting is required to finish the model. Tempera and acrylic colors can be used wherever paint is needed. Or the model can be sprayed with metallic or other paint and trimmed with contrasting colors. Found plastic shapes might also be introduced into the construction.

OTHER IDEAS

Look at some contemporary playgrounds for ideas. Actual equipment designs are sometimes extremely creative and really invite children to participate. Some present-day designers try to develop total playground environments for children which provide a number of stimulating activities in natural park or city or farm-like settings. This area of design is just beginning to be explored, and art students are easily involved in such activity where they can share a feeling of design pioneering.

TYPICAL PROBLEM

Design a model for playground equipment to meet one or more of the children's activity needs. Use colored cardboard and/or any other paper, cardboard or wood material in the model. Develop a sense of scale by using a child figure of heavy paper on the model. Paint as needed.

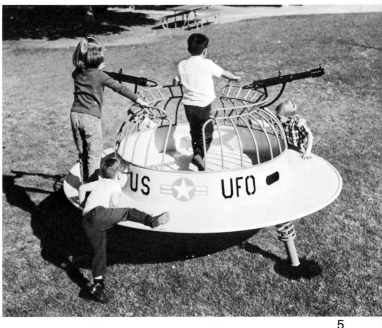

5

2

1

CARDBOARD/AND OTHER MATERIALS

Although cardboard is seldom considered as a construction material, it is very versatile and can be adapted to a wide variety of needs. It might be the underlying structure of a mask, or it might be a soaring sheet of black material describing a beautiful arc before a blank wall.

Cardboard can be adhered in gentle sweeps or it can be scored to make sharp edges and corners. It can be glued to wood strips for support the way sheet steel is welded to iron rods. It can be painted, upholstered, sprayed, dipped in plaster, covered with sculpmetal, or left unfinished. Various types and finishes are useful for a variety of purposes. Experiment.

OTHER IDEAS

Delightful masks can be made by developing cardboard under-shapes by scoring, cutting, and taping together. These can be covered with some cloth material, and features added using a variety of other materials: yarn, string, paper cups, ping pong balls, cut out shapes of cardboard, or other material, pieces of rug, scraps of paper or textiles and the like. The result is a series of highly creative pieces, making use of a number of design techniques and personal applications.

A structure emphasizing our world of visual symbols can be built using cardboard and wood sticks in combination to simulate street signs. An accumulation of ten or more of these can be arranged and mounted in a block of wood. Families of shapes can be placed together, or variety in shape and size can be emphasized. Signs can be painted or pasted on the cutout shapes, perhaps even cut from magazines

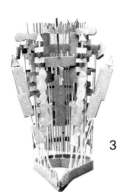

1. *Masks of cardboard, decorated with a variety of other materials, Le Conte Junior High School, Hollywood, California. (Los Angeles City Schools)*

2. *"Black Widow", a sheet steel stabile by Alexander Calder. Collection, The Museum of Modern Art, New York, Mrs. Simon Guggenheim Fund.*

3. *Paper and cardboard composition, Sun Valley Junior High School, Sun Valley, California. (Los Angeles City Schools)*

4. *Wood and cardboard structure in form of a walking man, Jefferson High School, Los Angeles, California. (Los Angeles City Schools)*

5. *A composition exploring the use of directional signs and symbols begins with bits of cardboard and employs lots of imagination. Lutheran High School, Los Angeles, California.*

6. *"The Duchess of Alba", welded sheet steel and rod sculpture by Reuben Nakian, courtesy Los Angeles County Museum of Art.*

3

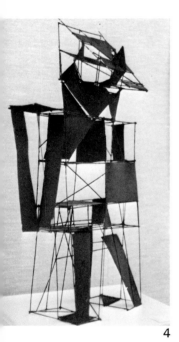

4

5

and collaged together. European visual symbols make excellent accents to our own verbal signs—or the signs might be left blank, emphasizing the shapes. Imagination and tongue-in-cheek satire can produce thoughtful and provocative results. Cardboard in combination with wood dowels, applicator sticks, or reed can produce dramatic shapes and exciting sculptural compositions. Because the pieces of cardboard become "tired" and have a tendency to bend, they can be reinforced with pieces of wood material. Such thin wood strips can be glued and held in place with clamps until dry. These constructions can be sprayed black to simulate sheet metal sculptures reinforced with steel rods. Applications of this technique can be expanded with a thoughtful imagination and plenty of encouragement, glue, and cardboard.

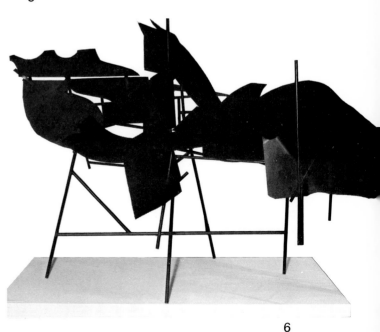

6

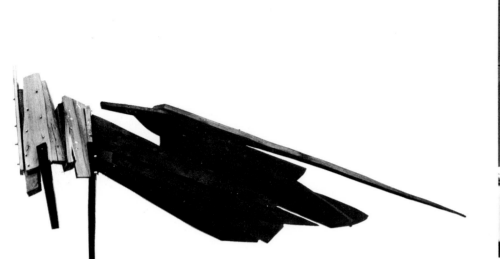

1

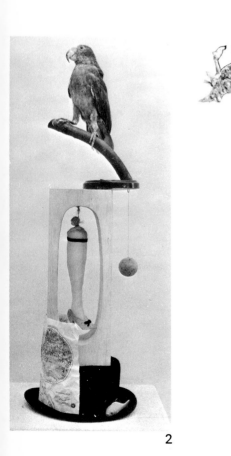

2

3

Chapter V
ASSEMBLAGES

INTRODUCTION

Assemblages became an important part of the major art scene early in the twentieth century with the collages of Pablo Picasso. He continued the trend he started by constructing small cubist objects from bits of wood and cardboard. Georges Braque and Juan Gris followed by gluing and affixing a variety of materials to their oil paintings. Two-dimensional assemblages were made by fastening together cut or torn bits of paper, newspaper clippings, photographs, cloth, wood, metal, shells and other such material. Three-dimensional assemblages continued this gluing procedure by constructing structures using chairs, table parts, dolls, mannequins, parts of automobiles, boilers, cloth, wood, metal scrap, and even stuffed animals and birds.

Prior to the second World War, the art of assemblage was becoming more and more part of the world art scene. But, during the war years, interest waned. Now, however, a revival of interest has grown until assemblage has become an internationally practiced creative method.

Adaptations in schools can include such things as wood constructions, soldering together of small metal things such as watch and clock parts, putting a lot of

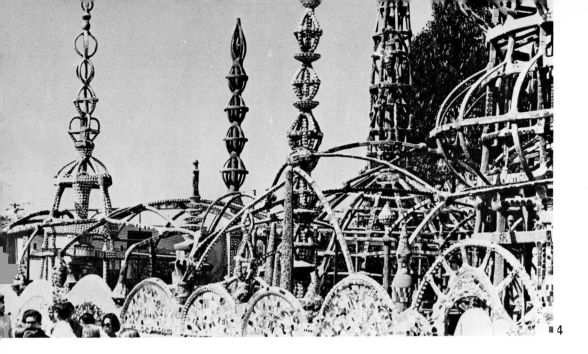

found objects in boxes or arranging them in upright drawers, placing typewriter parts on pedestals, gathering any number and variety of formed wood or metal parts and assembling them into designed and interesting shapes. Junk sculpture is assemblage, but the thing that makes it sculpture is the design factor. Placing the parts together in interesting and well-proportioned ways takes junk out of its former realm and transfers it by association into designed sculpture. When a student can see enough beauty in an old typewriter part that he wants to place it on a stand and enjoy it, he has learned to see, and the teacher has done a job of instructing. The fun of constructing assemblages doesn't fall to students alone, but a great many professional artists are producing beautifully designed work.

One of the saddest of the situations occurs when a teacher has access to a large supply of surplus items, like glass, metal parts, wood or found objects, and doesn't know how to get students to appreciate the qualities of these things. Here, in the assemblage, is an answer.

ASSEMBLAGE/MOSTLY WOOD

All sorts of wood pieces, turned, sawed, cut, or smoothed by sand and waves, are prime candidates

1. "Last Victory", hardwood assemblage by Erik Gronborg.
2. "Poetic Object", an assemblage of Joan Miro, composed of stuffed parrot, wood perch, stuffed silk stocking with velvet garter and paper shoe suspended in cutout frame, derby hat, hanging cork ball, celluloid fish and engraved map. Collection, The Museum of Modern Art, New York, gift of Mr. and Mrs. Pierre Matisse.
3. Assemblage of old watch works mounted on wood by Reinhold Marxhausen.
4. Simon Rodia's towers are an assemblage of steel, cement, bottles, shells, bottle caps, rocks, broken tile, old pieces of cement, and numerous objects found on or near the site. Watts, California.
5. Spoons and rocks form assemblage by Reinhold Marxhausen.

1

2

to end up in wood assemblages. A great many examples of such structures can be found in the section on wood constructions, while the ones illustrated here use several materials, but mostly wood.

MATERIALS

Wood of all types, from fresh cut lumberyard scraps to antique table legs from grandma's attic are useful. Bits of sand-smoothed driftwood are wonderful pieces for those near enough to a shoreline to be able to accumulate some. Usually a scrap bin or rummaging through a garage or attic will turn up enough parts for several structures. How about splintered baseball bats, weathered shingles, charred logs, weather-beaten tree stumps, table legs, picture frame parts, wooden handles, spools, or throw-away scraps from woodshop classes. All these and many more can be raw materials for wood assemblages. And what can be used with the wood? You name it! Rocks,

beach pebbles, old parts of musical instruments, bits of textured material, small metal scraps, nails, screws, bolts, bottles, stained glass, and on and on. Although such scrap parts may not be art objects in themselves, the careful and selective arrangement of several can produce a well-designed new unit that is pleasing to look at.

Adhesives are sometimes difficult to choose when such a variety of surfaces need to be stuck together. Epoxy glues are miraculous at times in gluing unlike surfaces together. White vinyl glue will hold many things, and an application to both surfaces allowed to dry, then another dose of glue, will usually produce a firm bond. Rubber bands or a wrapping of wire will hold the objects together until the glue has set. Some obstinate pieces might have to be wired *and* glued to insure a secure structure. Experiment with adhesives till one is suitable for your particular needs.

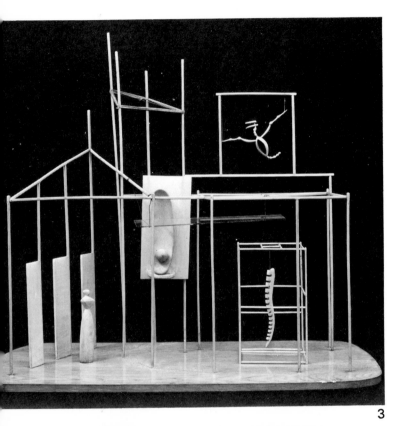

3

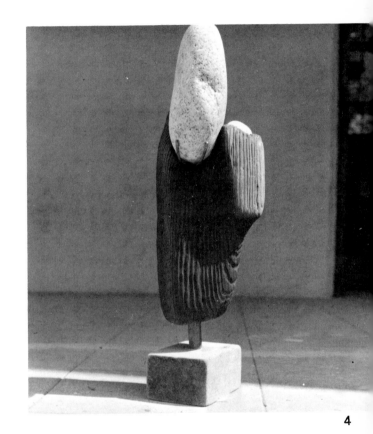

4

5

1. "New England Collage, II", composition of cedar shingles, asphalt roofing, tar paper, etc., nailed to painted board, by William Keinbusch. Collection, The Museum of Modern Art, New York.

2. Assemblage of clarinet parts and wood by Reinhold Marxhausen.

3. "The Palace at 4 A.M." a construction in wood, glass, wire, and string by Alberto Giacometti. Collection, The Museum of Modern Art, New York.

4. "Sculpture" wood and stone assemblage by Reinhold Marxhausen, owned by Late Prieto.

5. Assemblage of wooden crosses by Tom Mueller.

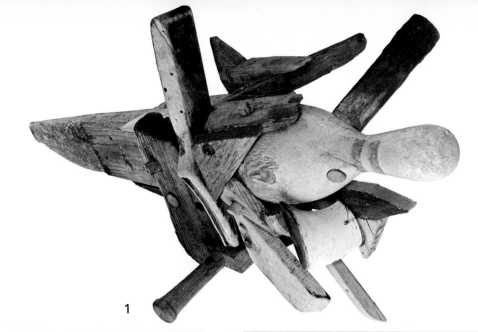

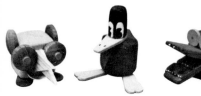

2

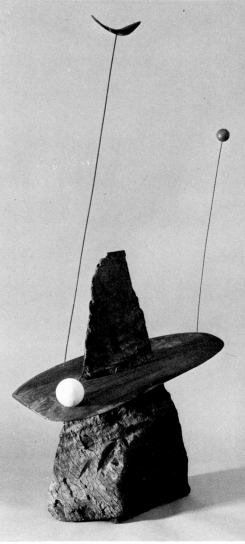

1. "Secret Weapon" driftwood assemblage held together with wooden pegs, by Roger Kuntz.

2. Little animal assemblages from Daniel Webster Junior High School, Los Angeles, California. (Los Angeles City Schools)

3. "Open Tombs", bronze and wood sculpture by Reinhold Marxhausen.

4. "Gibraltar", sculpture of lignum vitae, walnut and steel rods by Alexander Calder. Collection, The Museum of Modern Art, New York, gift of the artist.

5. "Vertigo Landscape", found wood and pierced tin can and metal assemblage by Seymour Locks. Collection, San Francisco Museum of Art, San Francisco, California.

PROCEDURES

Gather together a supply of wood and other parts, and make some trial arrangements without gluing. Select a key piece and begin to build from that. Add wood and/or other parts and glue or wire them in place. Watch for balance, rhythm, interesting arrangements of vertical pieces, suitable use of negative space, and appearance from all angles. Select materials that go well together—smooth against rough, light against dark, metal or stone against wood, mechanical against natural. Such relationships might well be the center of interest for the assemblage.

Some wooden assemblages might be put together with dowels and perhaps glued. Driftwood structures can be most attractive when worked in this way. Drill a ⅜ inch hole in both parts and force a ⅜ inch dowel into the holes to join the parts together. Such structures become extremely durable and solid.

TYPICAL PROBLEM

Take 3 to 8 scraps of wood and arrange them in a three-dimensional assemblage, to be free-standing. Introduce one other material, either metal or glass, to be contrasting in color or texture. Use suitable adhesives. Mount the structure on a ½ inch pipe set into a wooden block, unless the design calls for it to stand without an added base.

ASSEMBLAGES/MOSTLY METAL

Metal pieces in all sizes, shapes and descriptions can be assembled, joined, and presented as three-dimensional sculpture. While fabricating such structures might present serious problems in joining, some schools might have the equipment to make this challenging medium a reality in the art room. The photos presented might easily have application for other ways of working, or work in other media.

MATERIALS

Some artists prefer to work with scrap metal materials while others stick to clean and new sheet metal and/or rods and assemble their structures from them. Many constructionists rely only on metal, while others try to incorporate a great number of other materials; some wood, some plastic or glass, and some cloth or cardboard.

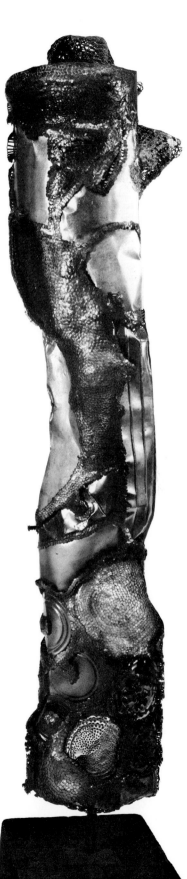

5

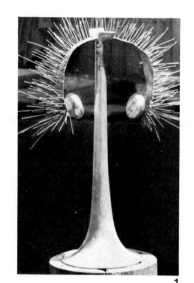

1

2

3

Ingenuity and quantities of patience and foresight are needed to produce interesting metal assemblages. It is the person who can see possibilities in all kinds of junk pieces that has the most fun assembling such structures. It takes imagination to see springs as arms, a refrigerator shelf as a chest, or chicken wire as hair. Gathering appropriate metal material might take some time. A large scrap box or shelf of metal parts is indispensable, but specific requirements might demand some out-of-class searching in junk yards, garages, or attics.

Parts must first be cleaned with solvents that will remove grease, dirt, or other foreign materials, before they are bolted, wired, soldered or welded together. The type of joining depends on the kinds of material. The size and weight of the structure and the availability of welding apparatus will also determine the kind of joining that has to be done. It is definitely easier to build a cleaner and stronger metal assemblage if welding facilities are available. However, wiring and sculpmetaling, or the use of epoxy glues can provide some strong and lasting bonds for such sculptures. Experimentation might provide heretofore untested remedies for some of these problems.

PROCEDURES

Gather large quantities of metal parts and keep them available in a large scrap box. Students can begin this project by gathering things for the box, not only things they will use themselves, but items that can replace the ones they might need.

Assemblages might follow a theme, might be abstract or might depict a figure or animal, and they might even be motorized to move.

Gather a number of pieces that will form a nucleus and begin adhering them together with whatever

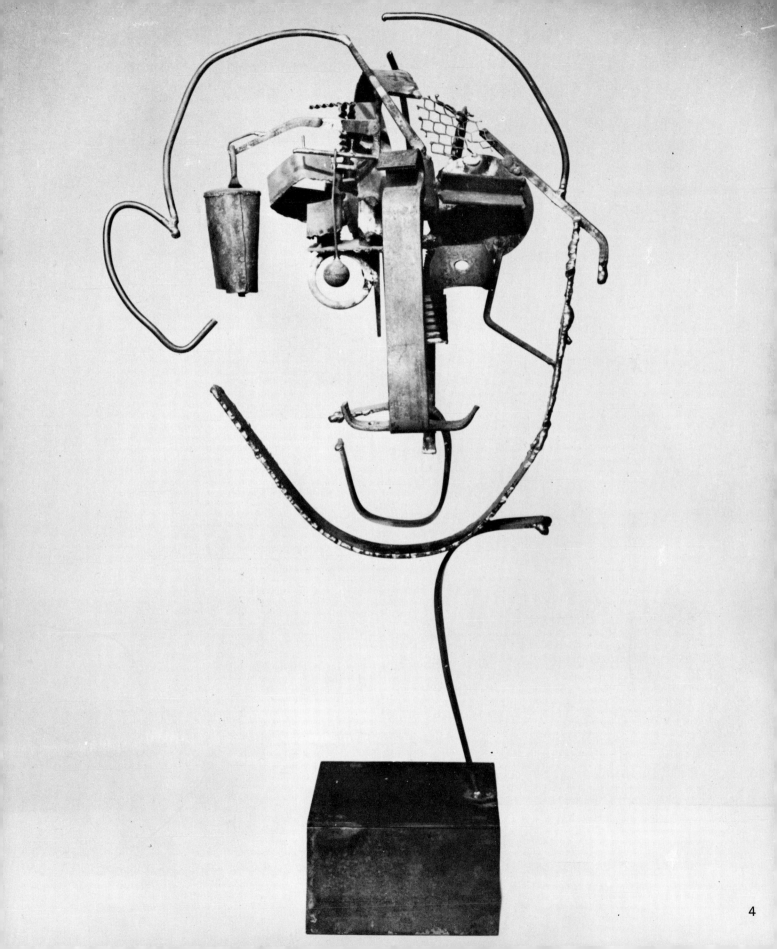

1

2

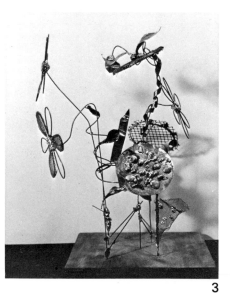

3

1. *"Atmosphere and Environment, I"*, a large aluminum structure by Louise Nevelson. Collection, The Museum of Modern Art, New York. Gift of Mrs. Simon Guggenheim.

2. *"Penn Railroad"*, gold leaf steel wall sculpture by William Bowie. Courtesy Pennsylvania Railroad and The Sculpture Studio, Inc., New York.

3. Construction of wire, screen, and copper sheet, Baltimore City Schools, Maryland.

4. *"Mounted Knight"*, assemblage of wood, tin, springs, and mixed media by William Accorsi. Courtesy American Craftsmen's Council, New York.

5. Assemblage using a trombone bell, wood, and brass by Reinhold Marxhausen.

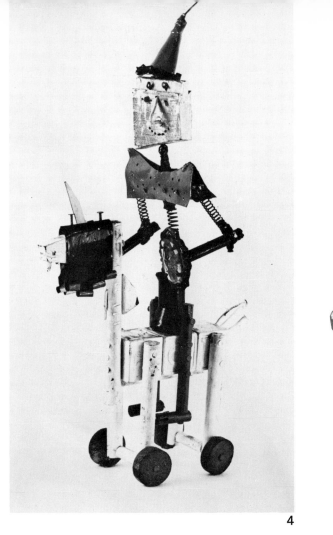

4

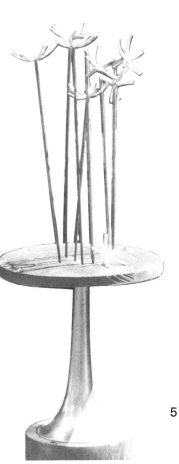

5

joining method is best. Make the material suggest arms, legs, or eyes, and don't feel compelled to represent every feature of a face, animal, flower or figure. Continue the addition of parts until a finished feeling is reached.

The completed assemblage can be painted, given a patina and mounted, or it might be given a clear coat of preservative material or allowed to further rust and discolor with oxidation.

OTHER IDEAS

Sometimes a mechanism such as parts of a clock or typewriter can prove interesting in itself, if it is given a finish and mounted.

Some work might have a definite finished quality while others might exude spontaniety and an unfinished feeling. Both can be exciting. The experimenta-

tion and construction are the important feature of the problem.

TYPICAL PROBLEM

Construct a human or animal figure using mostly metal material from the scrap bin. Keep the altering of pieces to a minimum, trying to assemble your figure by using only the pieces available. Use wire and epoxy glues to adhere pieces together. Paint the finished sculpture with bright acrylic colors and mount if necessary.

ASSEMBLAGES/FOUND OBJECTS

The assembling of a variety of found objects can be an exciting experience and lead students into the finding of interesting items wherever they might look. Art objects aren't only designed by a Picasso or a Calder, but utilitarian objects and pieces of junk can

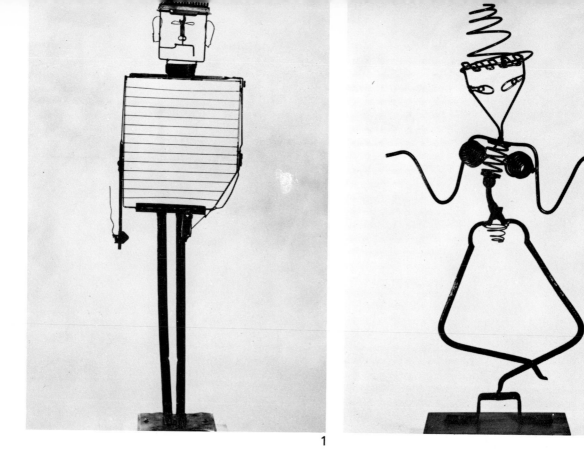

1 2

provide the components for fascinating assemblages. It is important that the young artists are aware of shapes, textures and colors as they look for items to use.

Building assemblages using found objects is a definite awareness producer.

MATERIALS

Almost any machine-manufactured and produced article, or hand-formed object can find its way into found-object assemblages. Only a very small sample list could include light bulbs, keys, bolts, pieces of musical instruments, bottles and/or bottle caps, dolls, rolling pins, old kitchen utensils, golf clubs, baseball bats and footballs, brushes, springs, refrigerator parts, radio parts, automobile parts, locomotive parts, driftwood, stones, and so on.

PROCEDURES

Such found objects can be placed into little boxes, big boxes, or old cupboard drawers. They can be welded, nailed or wired together. They can be glued together or mounted as they are found on blocks of wood or found pieces of driftwood.

In many cases it is the careful selection of pieces and the designed arrangement of the parts that produce the better assemblages. If it is tastefully done, the result can not only be interesting but beautiful. If done carelessly or without thought it can produce only a conglomeration of rearranged junk. It is this close difference between a good and a not-so-good assemblage that makes it a difficult way of working to teach others. But the sheer enjoyment of assembling such varieties of materials is worthwhile. Assemblages can evolve around favorite old things, nostalgic gifts, children's toys, sports, old keys, bits of school lore, stacks of old hinges or electrical equipment. Assemblages can develop into figures of people or animals or structures of ships, old automobiles, or abstract forms.

Some found-object assemblages need to be mounted on a base when completed, while others can be wall-mounted or may stand on their own. Painting or finishing is optional.

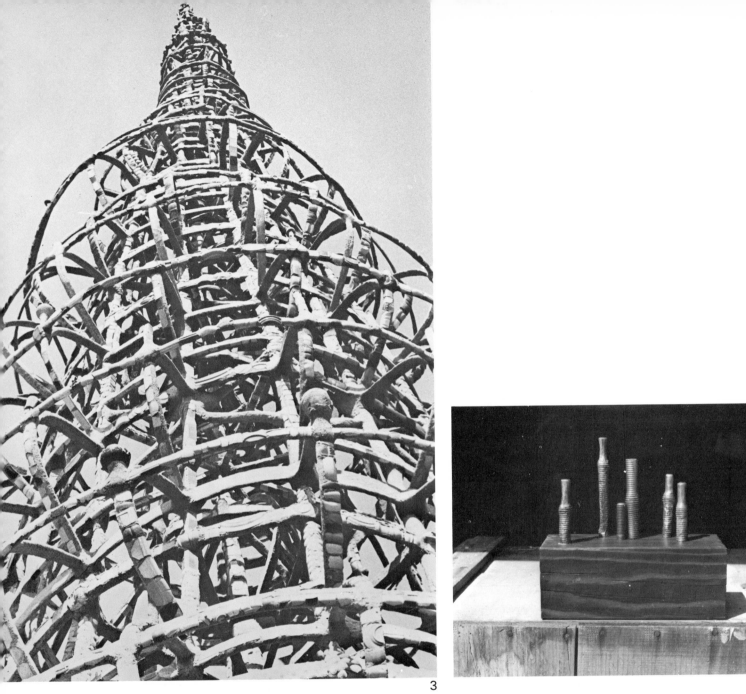

3

4

1. "Bully Boy", an assemblage by Nat Werner using a refrigerator shelf, carpet sweeper brush, bottle opener, an auto window frame and wire.

2. "Temple Dancer", assemblage using fireplace tongs, springs, potato masher and wire by Nat Werner.

3. Found objects abound in the decoration of Simon Rodia on his towers. Much of the material was found on the site of the structures and includes glass bottles, broken tile, and bits of junk. Watts, California. Courtesy of photographer Don Schweitzer.

4. "Bolt Family", collection of old bolts and a wood block by Reinhold Marxhausen.

5. Ship of old bottle and broken light bulbs, Concordia Teachers College, Seward, Nebraska.

5

1. *Drawer full of found objects, Le Conte Junior High, Hollywood, California. (Los Angeles City Schools)*

2. *Assemblage of saxophone keys by Reinhold Marxhausen.*

3. *"Golf Sculpture", variety of objects and steel, gold leafed, by William Bowie. Courtesy, The Sculpture Studio, Inc., New York.*

4. *"Box of Promise", assemblage of collected keys in strong wooden box, by Reinhold Marxhausen.*

1

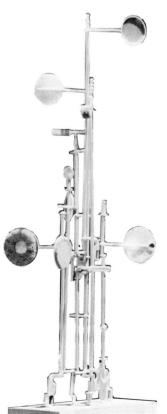

2

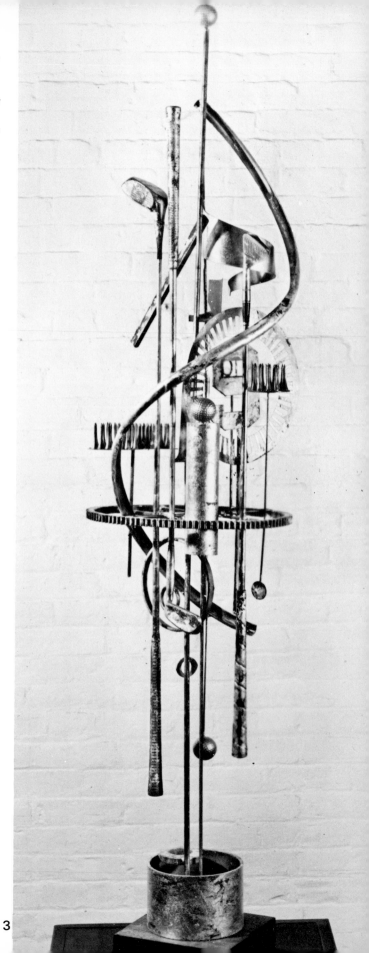

3

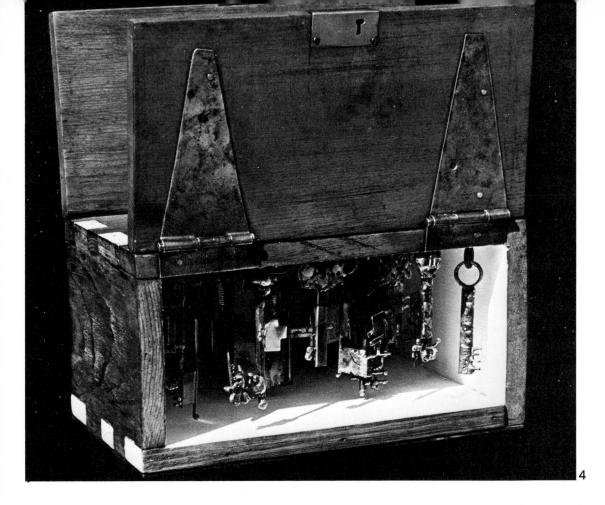

4

Chapter VI

CONCLUSION

Looking back over the vast number of photos and ideas presented can be pretty awesome, but this presentation is only a partial listing of working methods available to the contemporary artist. Many teachers and students, urged on by what they have found here, will develop still more ways of constructing things. And this is good, because the elements of change and continued development are essential to today's art scene. Two key words remain dominant throughout the book—experiment and change—and both teacher and student will continue to grow in direct proportion to their ability to experiment and change.

A FEW MORE IDEAS

It is essential to good teaching that students be exposed to as much contemporary design as possible. Teachers in large cities will find the task easier than those removed in miles from huge urban concentrations. However, don't overlook the study of the immediate environment for sources of ideas and in-

OTHER IDEAS

Objects can be placed into boxes with doors and will provide surprises when the doors are opened. A series of these boxes, stacked around each other, can be a mirth-provoking maze. Even broken parts of things are useful and are sometimes more effective than whole or complete objects, but care should be taken in keeping them in the scrap box if there is danger of cutting or tearing of clothes or fingers when rummaging around in the box.

TYPICAL PROBLEM

Gather found objects from home that are reminiscent of either childhood or teen-age life. Combine these into an assemblage, placing all the parts into a large box, providing shelves wherever necessary. Fill the box and vary the size of spaces for the objects. Paint the box with acrylic or tempera colors and glue the objects in place.

Many variations of the problem can be presented by changing the emphasis on contents.

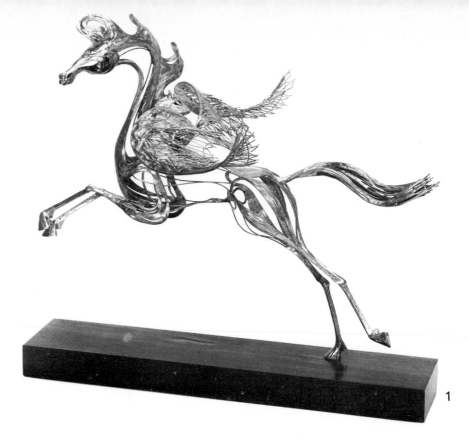

1

formation. Animals and plants and natural forms that are constantly nearby are often overlooked, and it is just these items that are vitally important to the local artist. Some suggestions for meeting the need for providing exposure to design ideas might include:

- trips to museums, galleries, and new architectural pieces
- subscriptions to any of several art and/or architectural magazines (highly illustrated)
- films or filmstrips on art and/or architecture
- use of community resource people in areas of art, architecture, design, advertising, etc.
- visits to advertising agencies
- visits to art schools
- begin developing art room library of books and magazines
- look at natural forms for ideas (trees, weeds, flowers, seed pods, rocks, etc.)
- look at animal and human forms (sketch, draw, and study actions and proportions on playground and physical education classes)

Pictures of contemporary and/or pertinent sculpture from catalogs, art magazines, and other magazine sources provide good motivational and bulletin board material. They also provide discussion starters and material to use as examples and comparisons.

SOME QUESTIONS

Questions that might be asked to begin discussions in class:

What role does sculpture play in various cultures; ancient, medieval, Renaissance, contemporary, etc?

How do social events influence the sculptor, and vice versa?

What is happening in sculpture today?

Is contemporary sculpture relevant to today's society, or acting independently of it?

How does present-day sculpture differ from that of the Renaissance period? Why?

How can sculpture be a form of visual communication?

Does sculpture have to be communication?

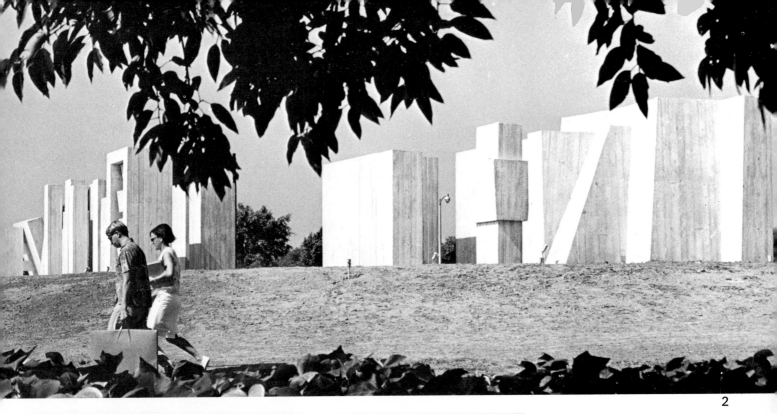

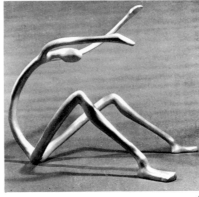

1. This flying horse of Russ Shears is so out of balance that motion is demanded. The intriguing mounting enhances the flowing lines to create strong feeling of movement.

2. "Homage to Sam Rodia" by J. J. Beljon is constructed in concrete of 19 massive pieces. California State College at Long Beach.

3. "Variation Number 7: Full Moon" by Richard Lippold is one of the world's greatest wire sculptures. Made of brass rods, nickel-chromium and stainless steel wire, it is ten feet high. Collection, The Museum of Modern Art, New York. Mrs. Simon Guggenheim Fund.

4. "Seated Man" is formed of Sculpmetal over a heavy wire armature. Courtesy of the Sculpmetal Company.

GLASS

Stained glass in chunks or sheet scraps
Colored glass
Bottle glass
Window glass
Auto glass (shattered)

WIRE

Stovepipe wire
Bell wire
Welding rods (different weights and
 lengths)
Aluminum wire
Coathangers
Galvanized steel wire
Copper and brass wires
Thin copper wires from unwound
 motor armatures
Carbon steel wire
Tie wire
Binder wire in boxes

SHEET METALS

Tin cans, larger the better
Aluminum sheet
Metal foils (household varieties)
Copper sheet
Offset photo plates (used)
Scrap from galvanized sheeting shops
Scrap from school metal shop

FOR TEXTURES

Nails
Staples
Pins
Washers
Sand
Gravel
Glue
Gesso
Modeling paste
String and twine
Gears
Nuts and bolts
Screen
Hardware cloth
Cloth material
Scraps of all types

OTHERS AND SPECIAL

Junk
Gears
Found objects
Straws
Pipe cleaners
String, thread, twine, yarn
Wood boxes
Cardboard boxes and containers

Mailing tubes
Pebbles
Stones
Watch and clock parts

BASIC TOOLS

Many of the construction problems require little if anything in the way of tools, however, sometimes they are needed to complete particularly difficult jobs or must be used when resistance cannot be overcome with fingers. Some tools that might be needed include:

METAL

Various pliers (round nose, needle nose)
Files
Rasps
Side cutters
Forming pliers
Hack saws
Jewelry saws
Tin shears
Soldering irons
Torches
Welding equipment

WOOD

Drills
Cutting knives
Files
Rasps
Coping saws
Staplers
Straight edges
Hammer
Other woodworking tools

GLASS

Glass cutters
Straight edges
Hammer
Pliers
Tile cutters

CARDBOARD AND PAPER

Scissors
Straight edges
Razor blades
Staplers
Punches
Knives

MATERIALS

WOOD FOR CONSTRUCTIONS OR SCULPTURE BASES

Balsa wood strips and sheets
Toothpicks
Applicator sticks
Reed
Doweling
Popsicle sticks
Tongue depressors
Wood scraps from school wood shop
Planks
Blocks

PAPER

Colored tissue paper
Construction papers
Corrugated cardboard
Chipboard
Tag board
Railroad board
Cardboards of all types
Scraps from art room

PLASTIC

Acetate sheets and scraps
Cellophane
Epoxies in tubes or cans
Liquid metals

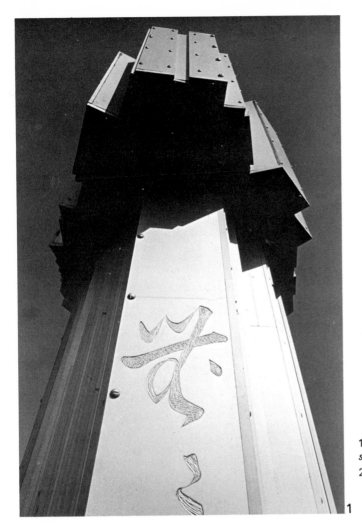

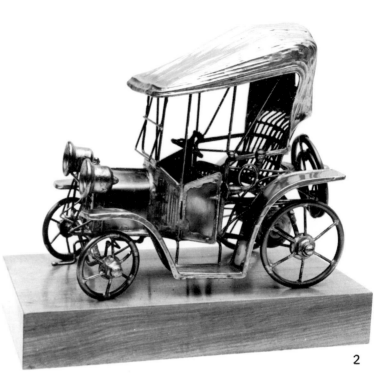

1. *"MU 464" by Kengiro Azuma is a ton and a half aluminum construction on the campus of California State College at Long Beach.*
2. *"Model T" a welded steel sculpture by Russ Shears.*

PHOTO CREDITS

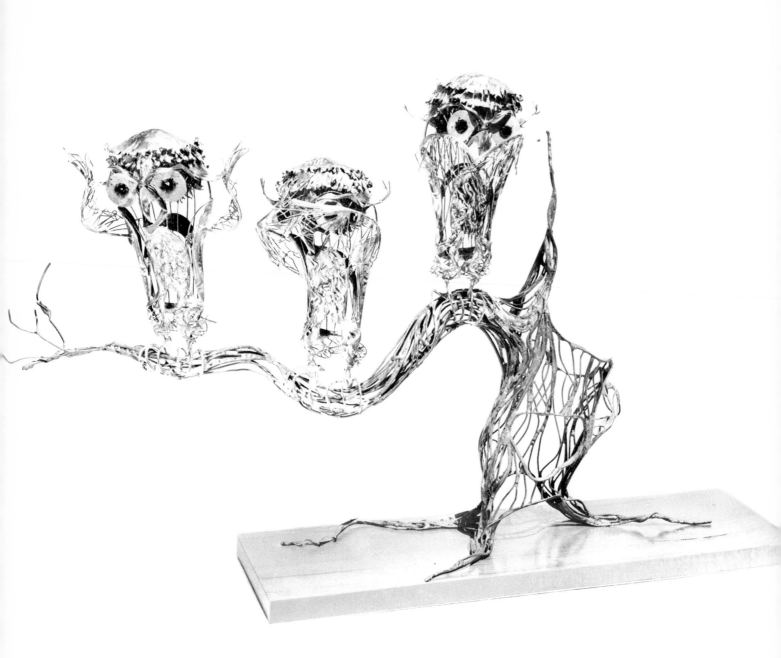

"Hear no Evil, See no Evil, Speak no Evil" is welded wire construction mounted on a flat walnut base. Work is by Russ Shears.

"Birds in Flight" by William Bowie is of welded wire and moves to give a feeling of flight.

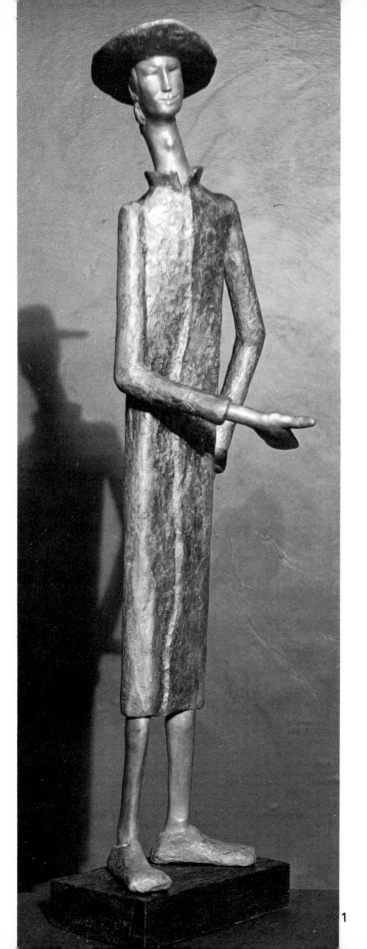

2

INDEX

1

HOW WE GO ON BEING FOUNDING FATHERS
FOR THE GENERATIONS TO COME

WHAT DO WE DO NEXT
THIS IS NOT AN EXHIBIT WITH A STATEMENT
IT IS AN EXHIBIT OF RAW MATERIALS
FOR PEOPLE TO MULL OVER
TO EXERCISE IMAGINATION ON WAR
TO FIND ALTERNATIVES TO POVERTY
TO PAIN

SHOULD WE HAVE GOTTEN FURTHER ALONG SINCE 76
SHOULD WE HAVE MORE IDEAS BY NOW

1. ''Shaker Man'' is constructed of sculpmetal over a mesh armature Part of the finish is polished and part left textured.

2. ''Untitled'' by Sol Le Witt. Detail of enamel on aluminum construction. Courtesy the Dwan Gallery, New York.

3. Detail of the box walls built by students of Immaculate Heart College, Los Angeles.

3

"Concrete Owl" by Lou Rankin is construction of concrete, steel and glass.

ACKNOWLEDGMENTS

I wish to express my thanks for the efforts of the many art educators throughout the United States for providing me with fine examples of student work. Without so many of them, there would be vast gaps in the illustrative material. My thanks to: Alan Cameron, Hubert Howe Bancroft Junior High School, Los Angeles, California; Gerald Citrin, Le Conte Junior High School, Hollywood, California; Arthur Geisert, Concordia Teachers College, River Forest, Illinois; John Harding, Webster Junior High School, Los Angeles, California; George Horn, Baltimore City Public Schools, Maryland; Al Hurwitz, Coordinator of the Arts, Associate in Education, Harvard University, Graduate School of Education; Frank Lane, Northridge Junior High School, Northridge, California; Larry Livingston, Jefferson High School, Los Angeles, California; Reinhold Marxhausen, Concordia Teachers College, Seward, Nebraska; Leon Mead, Florida State University, Tallahassee, Florida; Valrah N. Rountree, Otis Art Institute, Los Angeles, California; Roland Sylwester, Lutheran High School, Los Angeles, California; Joyce Theurkauf, Sun Valley Junior High School, Sun Valley, California; Virginia Timmons, Baltimore City Public Schools, Maryland; Charles H. Wagner, Parkville Senior High School, Baltimore, Maryland; Eugene White, Supervisor, Audio-Visual Section, Los Angeles City Schools, Los Angeles, California; Donald O. Williams, Secondary Art Supervisor, Los Angeles City Schools, Los Angeles, California.

My special thanks to George Horn for his constant encouragement and vital interest in the development of this project.

Many of the beautiful visual materials presented in this book, and those that make such a persistent impression on the reader, are the direct contributions of numerous of America's fine artists and craftsmen. Their keen interest in the book as it developed and their unselfish giving of material made the securing of information a pleasure. My thanks to: William Accorsi, New York; Glen Alps, Seattle, Washington; Barbara Blair, Carmel Valley, California; William Bowie, The Sculpture Studio, New York, New York; Stephen G. Brown, Los Angeles, California; Sister Mary Corita, Immaculate Heart College, Los Angeles, California; Eva Cossock, Tucson, Arizona; Robert Cronback, Westbury, New York; Roger Darricarrere, Los Angeles, California; Herbert A. Feuerlicht, New York; Dextra Frankel, Laguna Beach, California; Hana Geber, New York; Arthur Geisert, River Forest, Illinois; Erik Gronborg, Portland, Oregon; Mabel and Milon Hutchinson, Capistrano Beach, California; Luise Kaish, New York; David Kohl, Seward, Nebraska; Roger Kuntz, Laguna Beach, California; Mrs. Karl Larsson, Santa Fe, New Mexico; Eileen and John Lee, Block Island, Rhode Island; Robert Maki, Seattle, Washington; Reinhold Marxhausen, Seward, Nebraska; Warren Ostrus, Los Angeles, California; Lou Rankin, Laguna Beach, California; Russ Shears, Malibu, California; Robert Snider, Spokane, Washington; Nat Werner, New York; Richard Wiegmann, Seward, Nebraska; Westwood Winfree, Richmond, Virginia.

Museum and gallery directors were unstinting in their encouragement and help, and my thanks are expressed to: Mrs. Babitz, Committee for Simon Rodia's Towers, Watts, California; Earl Carter, Director, The Carter Gallery, Los Angeles; Kathy Church, Exhibition Secretary, San Francisco Museum of Art, San Francisco, California; Jean Godsman, Assistant Research Director, American Craftsmen's Council, New York; Charlotte Buel Johnson, Curator of Education, Albright-Knox Art Gallery, Buffalo, New York; Bertha Katznelson, Photographic Coordinator, Los Angeles County Museum of Art, Los Angeles, California; Phil Orlando and Bob Gino, Orlando Gallery, Encino, California; Nicole Sitterle, Assistant, Research and Education Department, American Craftsmen's Council, New York; Richard Tooke, Associate Supervisor of Rights and Reproductions, The Museum of Modern Art, New York; John W. Weber, Dwan Gallery, New York.

Several business and government officials were most cooperative in supplying visual material or other requested information for the book. My thanks to: Mr. Hallery, Societe de la Tour Eiffel, Paris, France; Warren Jamison, President, Jamison, Inc., Torrance, California; Judy Kaufman, Assistant to Public Relations Director, Chamber of Commerce of Metropolitan St. Louis, Missouri; R. W. Kohler, Advertising Manager, Trans-World Airlines, Los Angeles; John C. McComb, Manager, Public Relations and Advertising, Century City, Inc., Los Angeles; Judy Maul, Advertising Department, Trans-World Airlines, Los Angeles; J. A. Petrencs, General Manager, The Sculpmetal Company, Pittsburgh, Pennsylvania; M. D. Post, Manager of Press Relations, Bethlehem Steel Corporation, Bethlehem, Pennsylvania; Robert G. Wells, Manager, News Bureau and Publications, California State College at Long Beach; Alejandro del Viller, Manager, Subsecretaria de Turismo, Barcelona, Spain. And a special bit of thanks to Don Sweitzer for his excellent photographic help, especially his work on Simon Rodia's Towers, and to Bob Watson for some superb photocopying and printing.